420 Drawing Prompts - for - Stoners

www.orbiculuspublishing.com
Direct all inquiries to:
author@orbiculuspublishing.com
Copyright 2015 Thomas H. Chester
All rights reserved.
ISBN-13: 978-1517080563
ISBN-10: 1517080568

Horizon

Vines

Best Date

Grace

Fluffy Cotton _____ | _____ Fireworks _____

_____ Soul Sisters _____ | _____ Parachute _____

Zombie

New Bong

Prince Charming

Deep Breath

Alligator

The White House

Embrace

Window

Strudel

Bubbles

Stress

Balloons

Chastity Belt

Hearing Voices

Smile

Model T

Dream Girl

Irked Oyster

Handcuffs

Rabbit Cage

Sultry Canine

Igloo Made of Dry Ice

Breakfast in Bed

Thanksgiving Feast

Covered Bridge

Haberdashery

Jiggle

Balance

Flagellum

Difference

Comfort

Evolution

Shy Camels

Jail Cell

Ecstasy

Peace

Vampire Party

Lozenge

Simplicity

Tranquil Doves

Christmas Tree Forest

Silence

Loyal Frenchman

Rotary Telephone

Stubby Toes

Inflated Cucumber

Sausage

Stapler

Attraction

Flannel

Your Mind

Fighting Clams

Confusion

Grief

Seek

Glow-worm

Zombie Cabbage

Unexpected Discovery

Egg-Beater

Toys for Delinquents

Shattered Coffee Mug

Paper Flowers

Forbidden Garden

Folded Napkin Animal

Sag

Spider on Nose

Queer Anteater

Ocean Travel

Vintage

Adventure

Cruelty

Time Machine

Harmony

Wind-Up Dog

Matchbook

Outside the Wall

Circus Train

Discombobulate

Loneliness

Beach

Bad Directions

Volcano with Magma

Ultimate Pizza

Excited Chicken

Determination

Sickle

Messy Children

Heavy Metal

Cheery Vegetables

Baboons playing Catch

Interlinked Rings

Focus

Faith

Lighthouse

Vibrator

Nuclear Explosion

Fat Fairies

Bird Droppings

Metamorphosis

Briefs

Disaster

First Kiss

Moose on Train

Hopeful Caterpillar

Fear

Organic Spinach

Wind-up Watch

Fig Tree

Reality

Music for Deaf People

Book of Spells

Blubber

Sadness

Romantic Cow

Music

Muskrat

Wizard

Inside-Out Squirrel

Tiger Mouth

Enthusiastic Accountant

35

Wet Socks

Dream Boy

Inappropriate Pets

Mountain Tricycle

Today

Cute Pumpkin

Grandfather Clock

Numbers

Rice

Antique Ultrasound

Rare Jewel

Lizard Orthodontics

Home Sweet Home

Circles

Broccoli

Intuition

Candle Shop

Baby Dragon

Martian Landscape

Mohammed

Miracle

Knots

Santa List

Good Weather

Pregnant Hippo

Dare

Family

Nuns on Pogo-Sticks

Bazooka

Mushrooms

Forbidden Realms

Puzzle Pieces

Lightening

Hide-and-Seek

Courageous Sheep

Alternate Fuel

Sleeping Postman

Clean

Baby Wrestling

Goblin

Sexy Feline

Rhythm

Fairy Castle

Stretching Penguins

Rustic Computer

Kittens and String

Church

Rocking Chair

Hero

Magic Locket

Noodles

Forest of Pines

Vulcan Ears

Shower Curtain Rings

Stunt Car Jumping

Best Friends

Giants

Hairbrush for Bald Men

Archery Target

Baffled Spatula

Fallopian Tubes

Monks

Apple Pie

Sexy Legs

Sprout

Rattle-Snake Eggs

Soft Touch

Lion Tamer

Mysterious Tuna

Alive

Slug God

Bubbles

Termite Damage

Hug

Sharp Tacks

Rainbow

Rabbit

Skip

Pony Express

Hail

Singing Dinosaurs

Impossible Puzzle

Sponge

Spaceship

Relax

Bloom

Strange Font

Too Hot Sauce

Pirate Booty

Thunderstorm

Marshmallows

Elephant on Unicycle

Reclining Chair

Cashew Nuts

Experience

Dreaming Dog

Goat Beard

Corn on the Cob

Tomatoes

Britches

———— Unique Tic-Tac ———— ———— Waterfall ————

———— King of Mushrooms ———— ———— Sassafras Root Beer ————

Bananas in Sauna

Little Lion

Scary Castle

Dancing Bears

Sneaky Flamingo

Mousetrap

Lawyer

Enchanting

Frog Playing Guitar

Sharing Eels

Arrogant Sofa

Robot Hamster

Helicopter Battle

Sewing Cats

Convertible

Open-heart Surgery

Grass

Crazy Mustache

Bamboo Couch

Pickles

Cry

Release

Socks in Box

Mountains and Molehills

Pudding Pool

Positive Energy

Forgiveness

Bat Cakes

Sprockets

Safety

Scruffy Hipster

Belly-Dancing Porcupine

Quicksand

Follicle

Wedding Ring

Stars

Bent Spoon

Bunk Bed

Wad of Money

Angry Moths

Large Pants

Strength

Siamese Twins

Flying Car

Work

Troll

Bladder

Manhole

Gristle

Princess

Crowd of Crows

Childbirth

Burglar Pigs

Wobble

Eye Surgery

Scribble

Capsized Boats

House Made of Bacon

Art for Blind People

Hate

Spanks

Jumping Girls

Love

Gynecological Tools

Gash

Centipede

Winning Envelope

Angels

Parade of Fools

Lemon Tree

Booby-Trap

Church Bells

Hullabaloo

New Clothes

Recovery

Sailfish

Favorite Sandals

Solitary Tree

Skate Party

Surprise Party for German

Mechanical Computer

Tweezers

Staircase

Passion

Victory

Boy Eating Turnip

Fire Truck

Rubbish

Wisdom of Rodents ———— | ———— Scrumptious Cheese Ball ————

Sinking Boat ———— | ———— Ant Attack!

Missing Teeth ——— | ——— Darkness ———

Microphone ——— | ——— Paradise ———

Squid

Musical Notes

Lost Memories

Good Choice

Melting Ice

Sack of Doorknobs

Reflection

Shadow

Radishes in Love

Wonderful

Bravery

Leadership

Motorcycle

Laughter

Spirit

Mellow Canadian

Rainstorm

Why

Soul

Yes

Bad Advice

Hunger

Swan

Sleep

Naked Snails

Joint

Beetle Foreplay

Path Not Taken

River of Tears

Snowman Funeral

Spirals

Togetherness

China Doll

Blimp

Anxiety

Big Bang

Healing Flower

Goon

Belly-Button

Enema

Ninjas

Bowling Balls

Vintage Radio

Broken Vase

Swollen Hands

Loch Ness Monster

Toothbrush

Bulbous Potato

Magical Building

Water Wheel

Compassion

Banjo Factory

Queen of Butterflies

Mischief

Cougar

Walrus Giving Birth

Paper Airplane

Machete

Proud Pencil

Deceptive Desire

Childhood

Illusion

Happiness

Crazy Invention

Discipline

Junk

Surfing Waves

Conquistadors

Deflated Basketball _____ _____ Duty _____

Fire _____ _____ Beauty _____

Anorexic Manatee

Talisman of Power

Exploding Sun

Falling Leaves

Slender Fingers

Ducks Jumping Rope

Clouds

Flabbergasted Blender

Chicken Beaks

Abandoned Sidewalk

Hockey Stick

Giant Blister

Wings

Wooden Shoes

Extra Foot

Shenanigans

Boredom

Dental Exam

Thrill-Ride

Wishing Well

CPSIA information can be obtained at www.ICGtesting.com
Printed in the USA
LVOW10s2200040116

469140LV00020B/596/P

9 781517 080563

THE TRANSFORMERS
SPOTLIGHT
VOLUME 2

IDW Publishing • San Diego, CA

THE TRANSFORMERS SPOTLIGHT

VOLUME 2

Collection edits and Design by Dene Nee
Additional Design by Neil Uyetake
Cover by Gabriel Rodriguez

Licensed By:

Special thanks to Hasbro's Aaron Archer, Michael Kelly, Amie Lozanski, Ed Lane, Michael Provost, Val Roca, Erin Hillman, Jos Huxley, Samantha Lomow, and Michael Verrecchia for their invaluable assistance.

www.IDWPUBLISHING.com ISBN: 978-1-60010-154-0 13 12 11 10 2 3 4 5

Operations: Ted Adams, Chief Executive Officer • Greg Goldstein, Chief Operating Officer • Matthew Ruzicka, CPA, Chief Financial Officer • Alan Payne, VP of Sales • Lorelei Bunjes, Dir. of Digital Services • AnnaMaria White, Marketing & PR Manager • Marci Hubbard, Executive Assistant • Alonzo Simon, Shipping Manager • Angela Loggins, Staff Accountant • Cherrie Go, Assistant Web Designer • Editorial: Chris Ryall, Publisher/Editor-in-Chief • Scott Dunbier, Editor, Special Projects • Andy Schmidt, Senior Editor • Bob Schreck, Senior Editor • Justin Eisinger, Editor • Kris Oprisko, Editor/Foreign Lic. • Denton J. Tipton, Editor • Tom Waltz, Editor • Mariah Huehner, Associate Editor • Carlos Guzman, Editorial Assistant • Design: Robbie Robbins, EVP/Sr. Graphic Artist • Neil Uyetake, Art Director • Chris Mowry, Graphic Artist • Amauri Osorio, Graphic Artist • Gilberto Lazcano, Production Assistant • Shawn Lee, Production Assistant

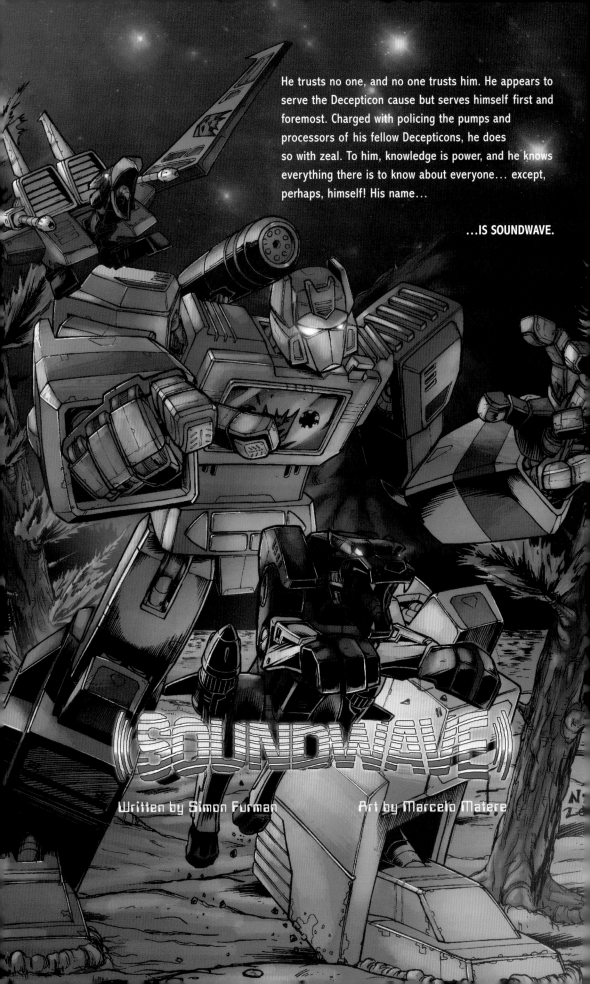

He trusts no one, and no one trusts him. He appears to serve the Decepticon cause but serves himself first and foremost. Charged with policing the pumps and processors of his fellow Decepticons, he does so with zeal. To him, knowledge is power, and he knows everything there is to know about everyone… except, perhaps, himself! His name…

…IS SOUNDWAVE.

SOUNDWAVE

Written by Simon Furman Art by Marcelo Matere

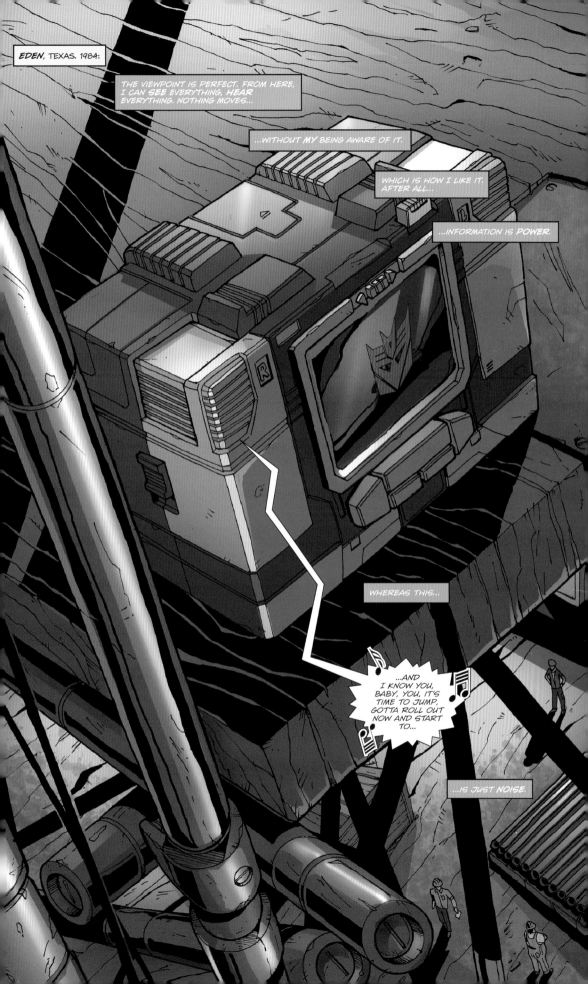

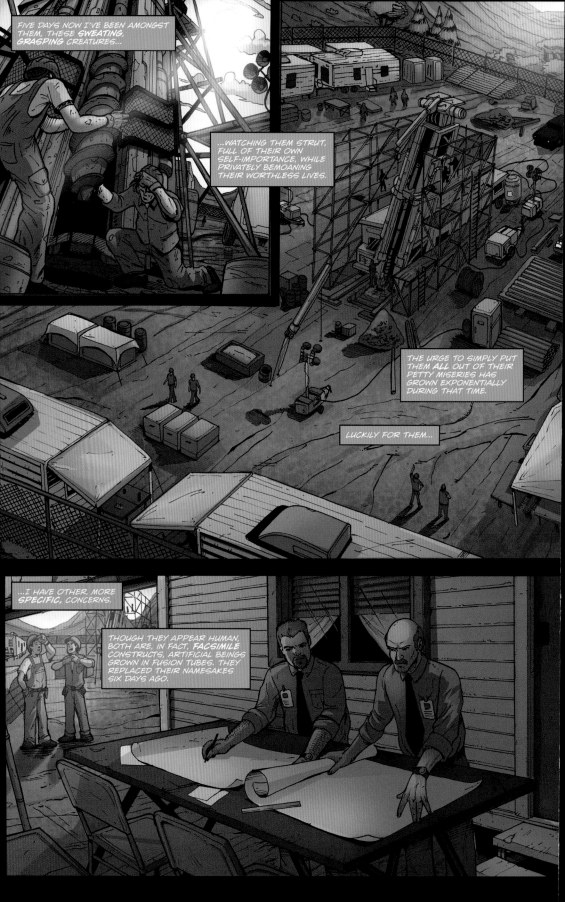

FIVE DAYS NOW I'VE BEEN AMONGST THEM, THESE SWEATING, GRASPING CREATURES...

...WATCHING THEM STRUT, FULL OF THEIR OWN SELF-IMPORTANCE, WHILE PRIVATELY BEMOANING THEIR WORTHLESS LIVES.

THE URGE TO SIMPLY PUT THEM **ALL** OUT OF THEIR PETTY MISERIES HAS GROWN EXPONENTIALLY DURING THAT TIME.

LUCKILY FOR THEM...

...I HAVE OTHER, MORE **SPECIFIC**, CONCERNS.

THOUGH THEY APPEAR HUMAN, BOTH ARE, IN FACT, **FACSIMILE** CONSTRUCTS, ARTIFICIAL BEINGS GROWN IN FUSION TUBES. THEY REPLACED THEIR NAMESAKES SIX DAYS AGO.

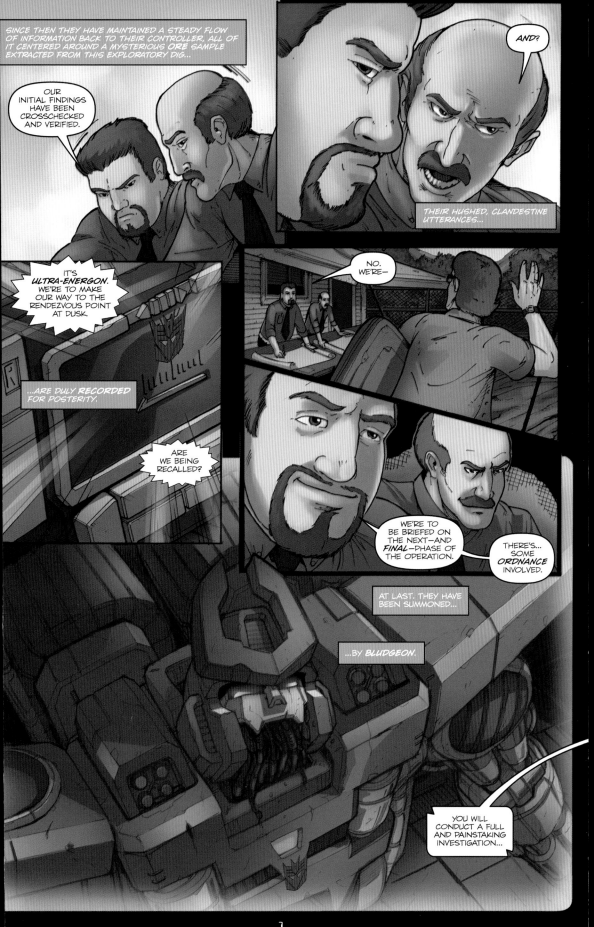

SINCE THEN THEY HAVE MAINTAINED A STEADY FLOW OF INFORMATION BACK TO THEIR CONTROLLER, ALL OF IT CENTERED AROUND A MYSTERIOUS *ORE* SAMPLE EXTRACTED FROM THIS EXPLORATORY DIG...

OUR INITIAL FINDINGS HAVE BEEN CROSSCHECKED AND VERIFIED.

AND?

THEIR HUSHED, CLANDESTINE UTTERANCES...

IT'S *ULTRA-ENERGON.* WE'RE TO MAKE OUR WAY TO THE RENDEZVOUS POINT AT DUSK.

...ARE DULY *RECORDED* FOR POSTERITY.

ARE WE BEING *RECALLED?*

NO. WE'RE—

WE'RE TO BE BRIEFED ON THE NEXT—AND *FINAL*—PHASE OF THE OPERATION.

THERE'S... SOME *ORDNANCE* INVOLVED.

AT LAST. THEY HAVE BEEN SUMMONED...

...BY *BLUDGEON.*

YOU WILL CONDUCT A FULL AND PAINSTAKING INVESTIGATION...

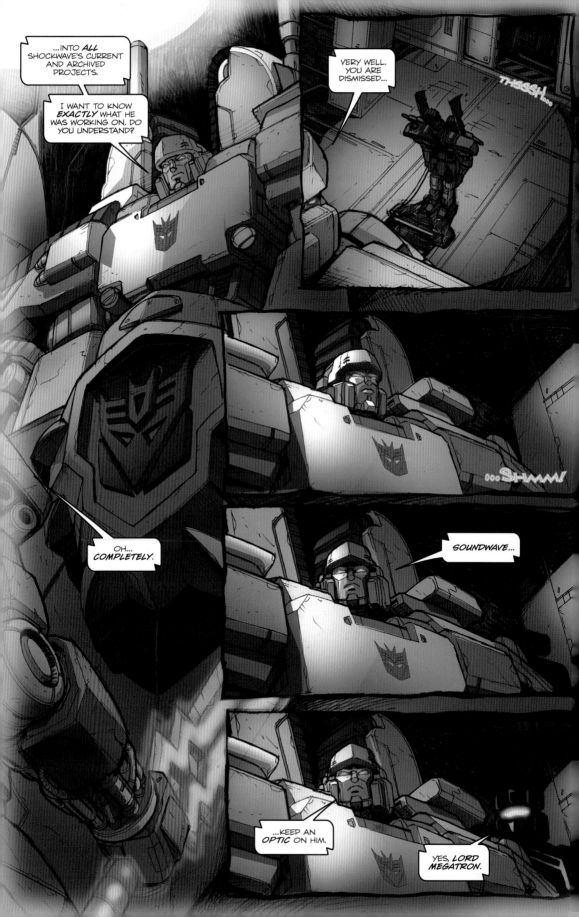

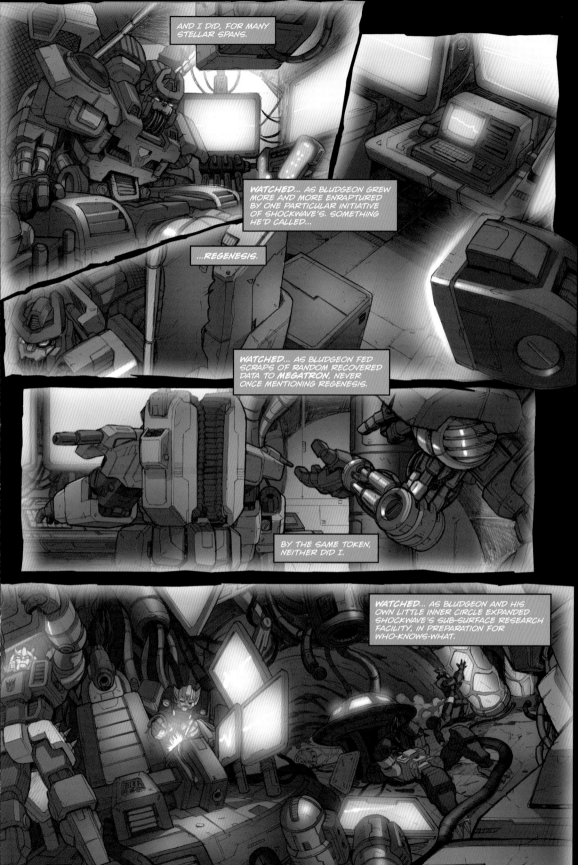

AND I DID, FOR MANY STELLAR SPANS.

WATCHED... AS BLUDGEON GREW MORE AND MORE ENRAPTURED BY ONE PARTICULAR INITIATIVE OF SHOCKWAVE'S. SOMETHING HE'D CALLED...

...REGENESIS.

WATCHED... AS BLUDGEON FED SCRAPS OF RANDOM RECOVERED DATA TO MEGATRON, NEVER ONCE MENTIONING REGENESIS.

BY THE SAME TOKEN, NEITHER DID I.

WATCHED... AS BLUDGEON AND HIS OWN LITTLE INNER CIRCLE EXPANDED SHOCKWAVE'S SUB-SURFACE RESEARCH FACILITY, IN PREPARATION FOR WHO-KNOWS-WHAT.

WATCHED... AS SOMETHING WAS *RECOVERED* FROM CYBERTRON'S DEPTHS AND THEN SEALED BEHIND BLAST DOORS AND GUARDED AROUND THE CLOCK.

WATCHED... AS—MUCH LATER, WELL AFTER CYBERTRON HAD BEEN OFFICIALLY DECLARED OFF-LIMITS—BLUDGEON, *IGUANUS* AND *BOMB-BURST* MADE PREPARATIONS FOR THE JOURNEY...

...TO *EARTH.*

AND...

...WE'RE *DONE.*

DON'T KNOW 'BOUT YOU, *HIRO,* BUT AH'M HEADED STRAIGHT TO THE LOCAL WATERING HOLE.

THANK YOU FOR THE INVITATION, BUD-SAN, BUT HAVING SPENT ONE EVENING IN YOUR "WATERING HOLE"...

...I FIND I HAVE NO GREAT DESIRE TO *REPEAT* THE EXPERIENCE.

EH, SUIT YOURSELF.

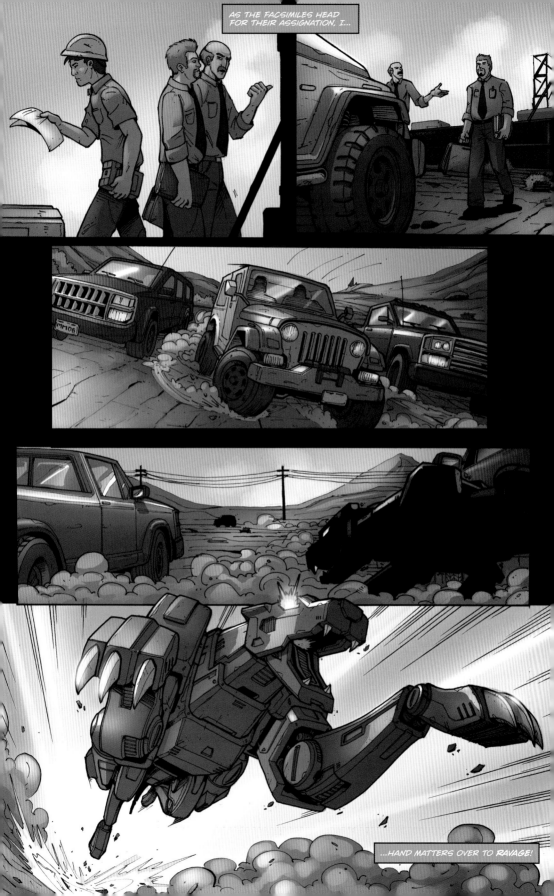

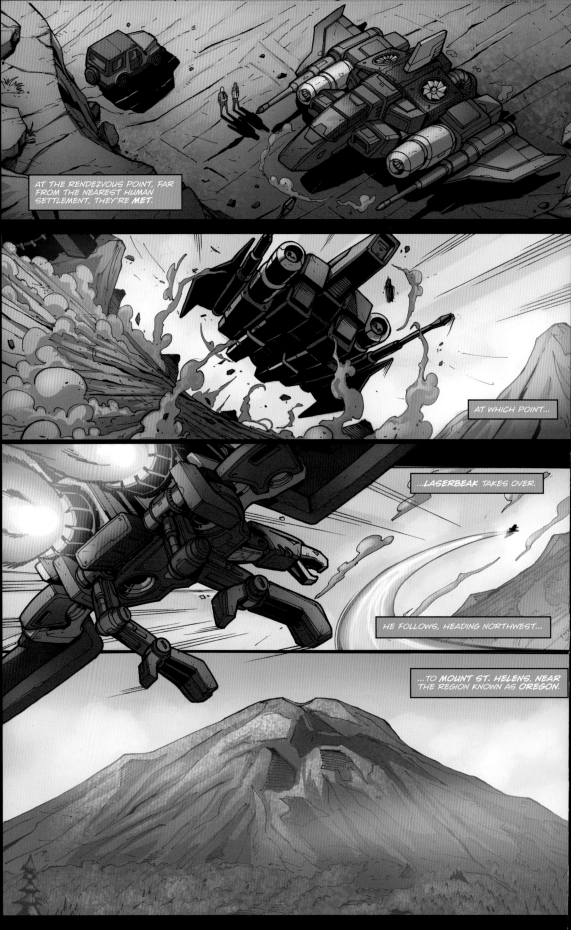

AT THE RENDEZVOUS POINT, FAR FROM THE NEAREST HUMAN SETTLEMENT, THEY'RE **MET**.

AT WHICH POINT...

...**LASERBEAK** TAKES OVER.

HE FOLLOWS, HEADING NORTHWEST...

...TO **MOUNT ST. HELENS**, NEAR THE REGION KNOWN AS **OREGON**.

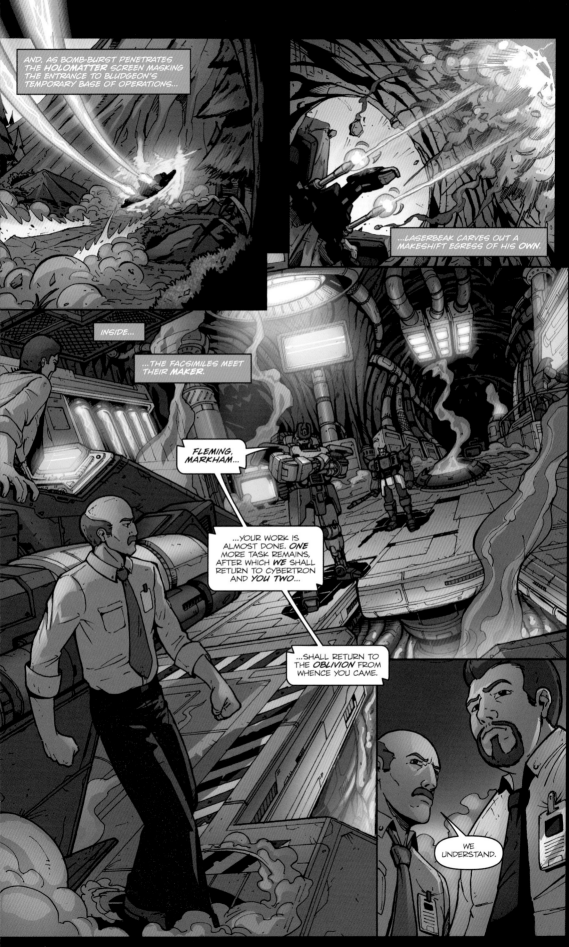

AND, AS BOMB-BURST PENETRATES THE *HOLOMATTER* SCREEN MASKING THE ENTRANCE TO BLUDGEON'S TEMPORARY BASE OF OPERATIONS...

...LASERBEAK CARVES OUT A MAKESHIFT EGRESS OF HIS *OWN.*

INSIDE...

...THE FACSIMILES MEET THEIR *MAKER.*

FLEMING, MARKHAM...

...YOUR WORK IS ALMOST DONE. *ONE* MORE TASK REMAINS, AFTER WHICH *WE* SHALL RETURN TO CYBERTRON AND *YOU TWO*...

...SHALL RETURN TO THE *OBLIVION* FROM WHENCE YOU CAME.

WE UNDERSTAND.

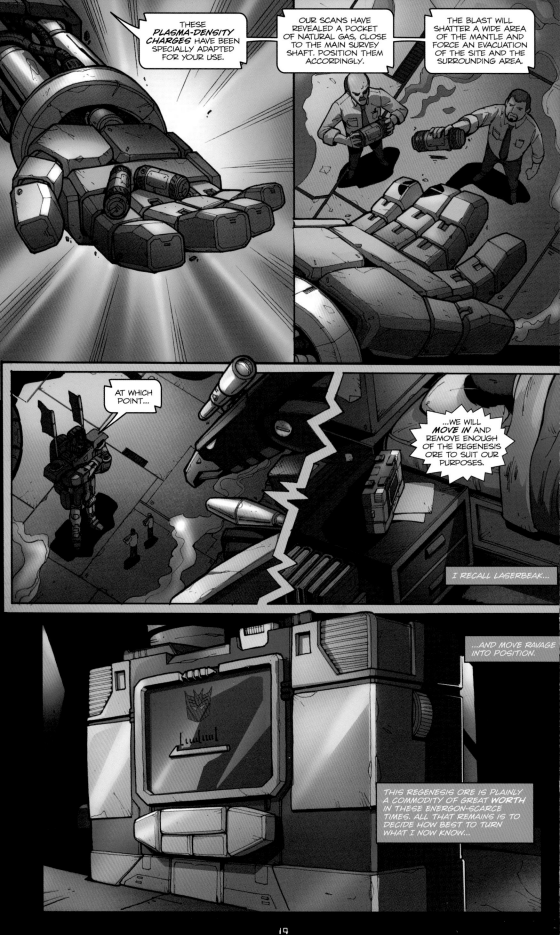

THESE **PLASMA-DENSITY CHARGES** HAVE BEEN SPECIALLY ADAPTED FOR YOUR USE.

OUR SCANS HAVE REVEALED A POCKET OF NATURAL GAS, CLOSE TO THE MAIN SURVEY SHAFT. POSITION THEM ACCORDINGLY.

THE BLAST WILL SHATTER A WIDE AREA OF THE MANTLE AND FORCE AN EVACUATION OF THE SITE AND THE SURROUNDING AREA.

AT WHICH POINT...

...WE WILL **MOVE IN** AND REMOVE ENOUGH OF THE REGENESIS ORE TO SUIT OUR PURPOSES.

I RECALL LASERBEAK...

...AND MOVE RAVAGE INTO POSITION.

THIS REGENESIS ORE IS PLAINLY A COMMODITY OF GREAT **WORTH** IN THESE ENERGON-SCARCE TIMES. ALL THAT REMAINS IS TO DECIDE HOW BEST TO TURN WHAT I NOW KNOW...

19

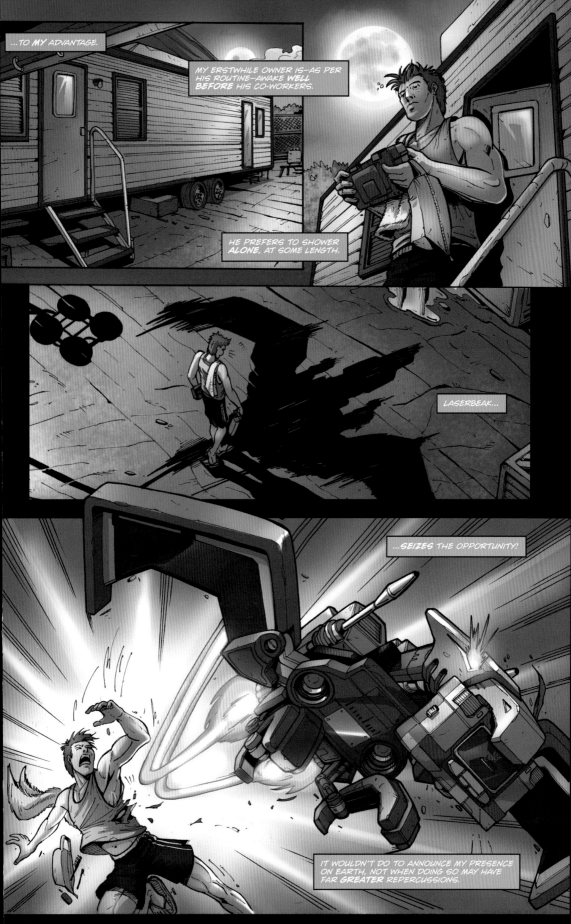

OF THIS FLEETING INCIDENT IN PARTICULAR, I IMAGINE *LITTLE* WILL BE SAID...

...AND EVEN *LESS* BELIEVED.

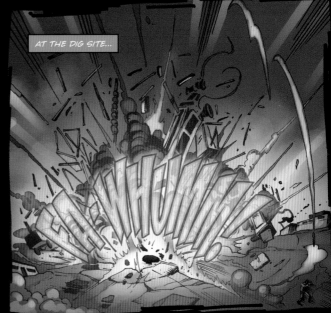

AT THE DIG SITE...

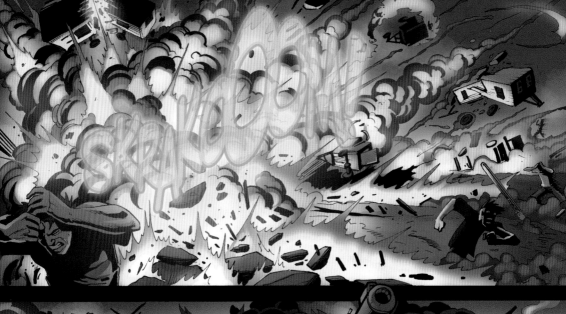

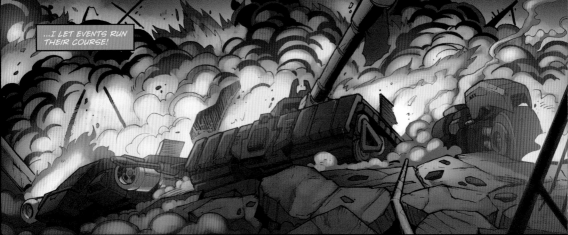

...I LET EVENTS RUN THEIR COURSE!

AND, BY THE TIME THEY'VE *GATHERED* THEIR HAUL AND RETURNED TO BASE...

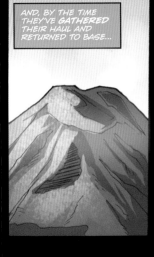

...I'M THERE WAITING.

MOMENTARILY DISORIENTED FROM THE *ORBITAL BOUNCE*, I LET THEM GATHER THEIR WITS...

...BEFORE ANNOUNCING MY PRESENCE!

GREETINGS, FELLOW DECEPTICONS!

EH—?

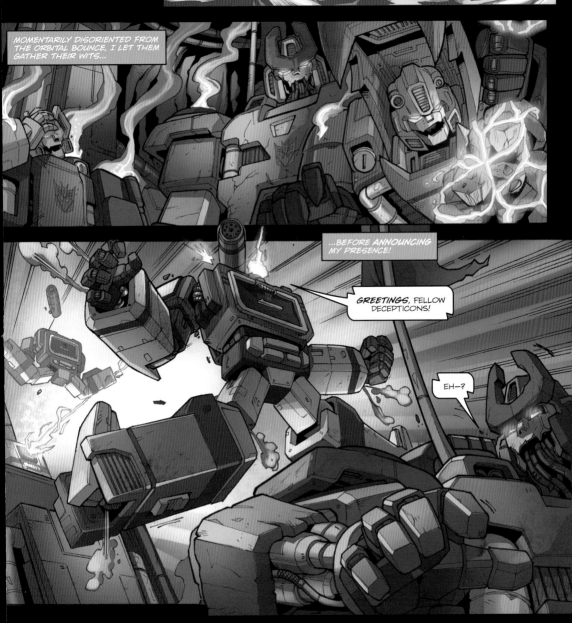

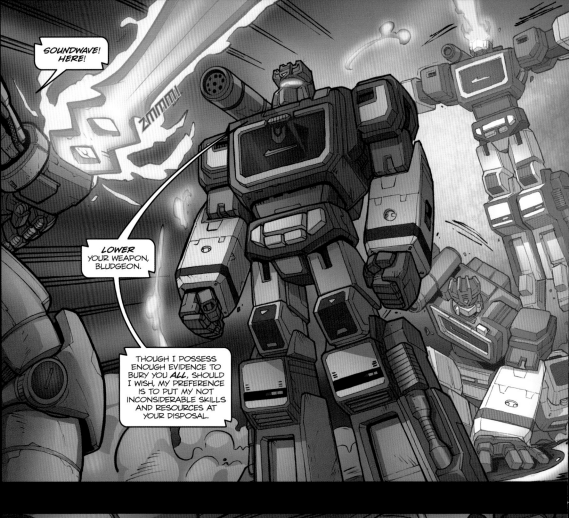

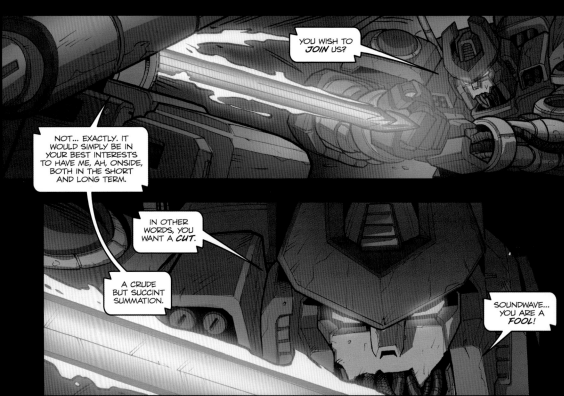

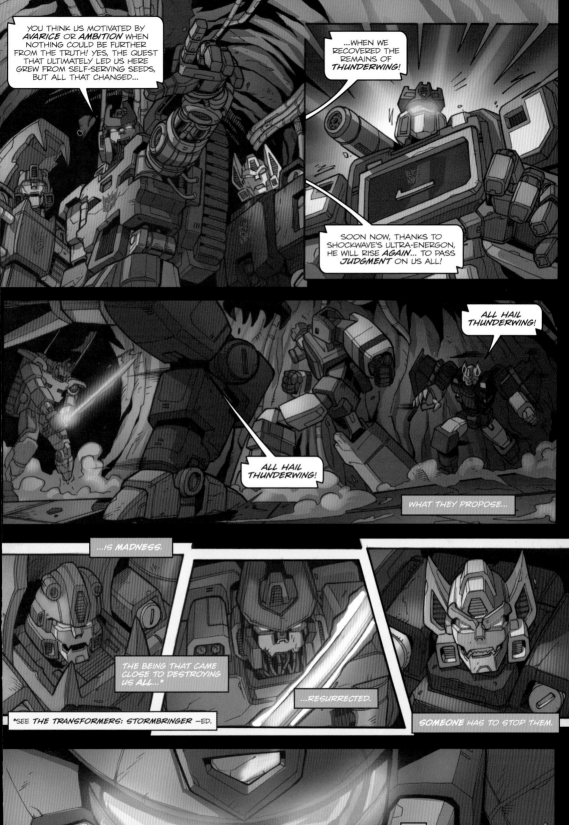

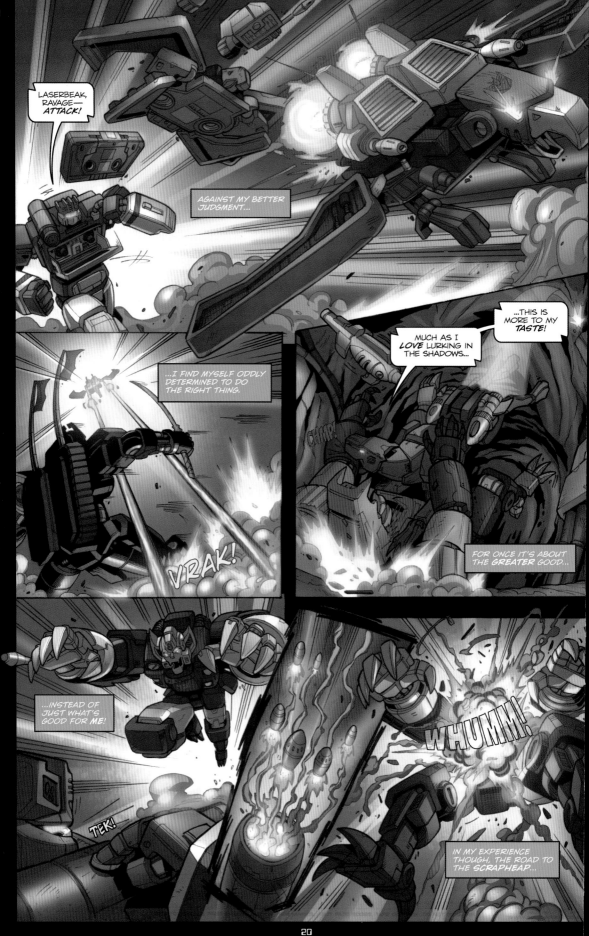

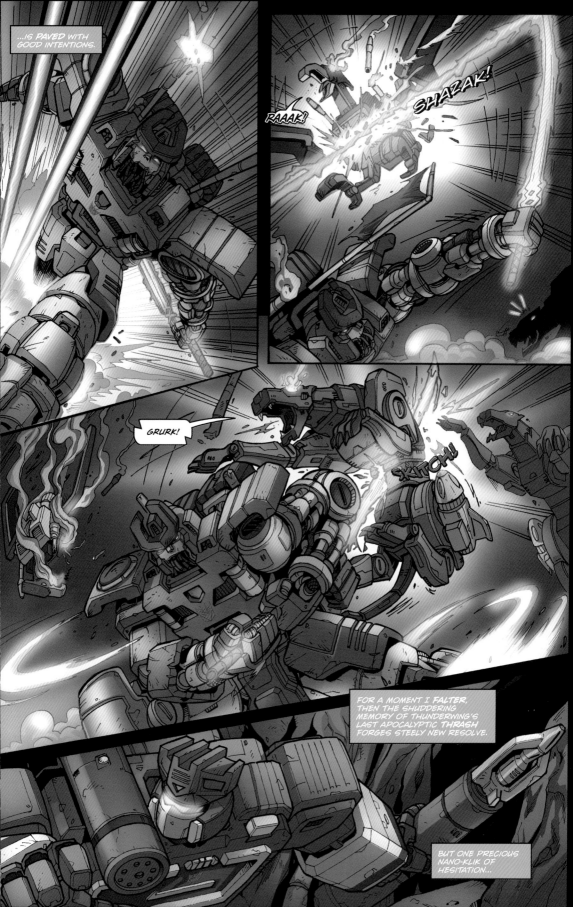

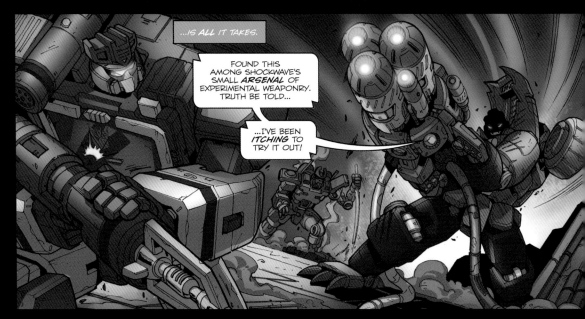

...IS *ALL* IT TAKES.

FOUND THIS AMONG SHOCKWAVE'S SMALL *ARSENAL* OF EXPERIMENTAL WEAPONRY. TRUTH BE TOLD...

...I'VE BEEN *ITCHING* TO TRY IT OUT!

EVEN IF I BEAT IGUANUS TO THE PUNCH, I CAN'T TAKE THEM *ALL*.

SO...

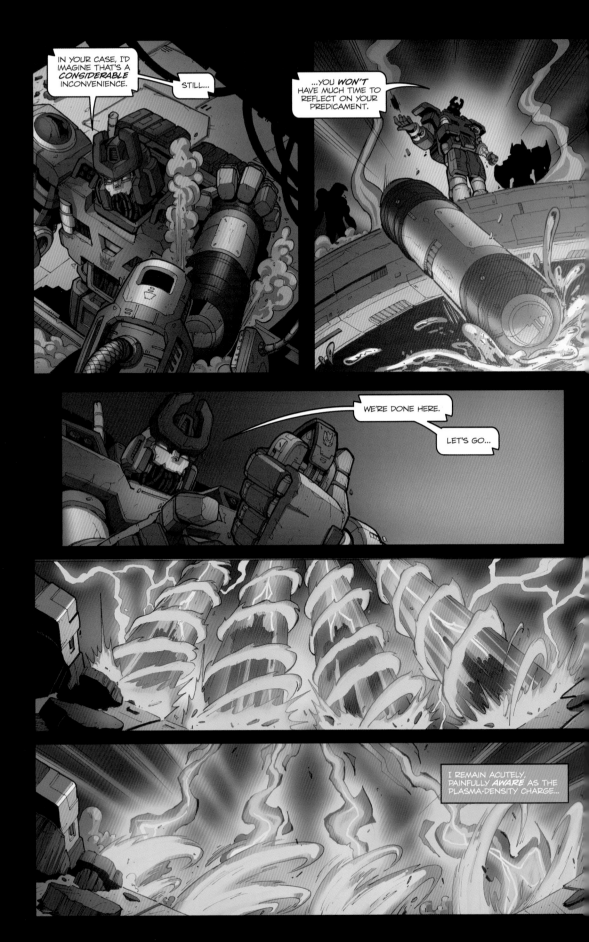

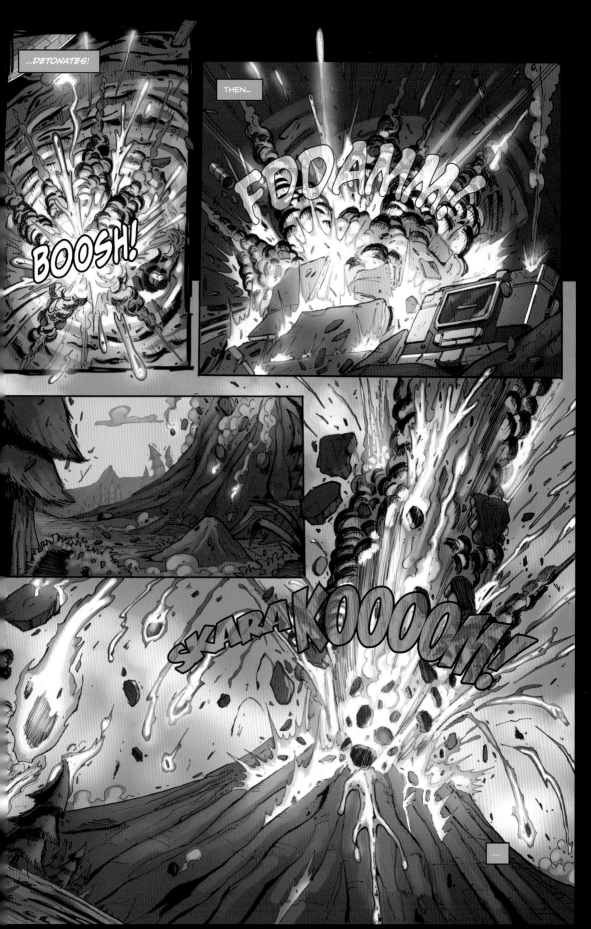

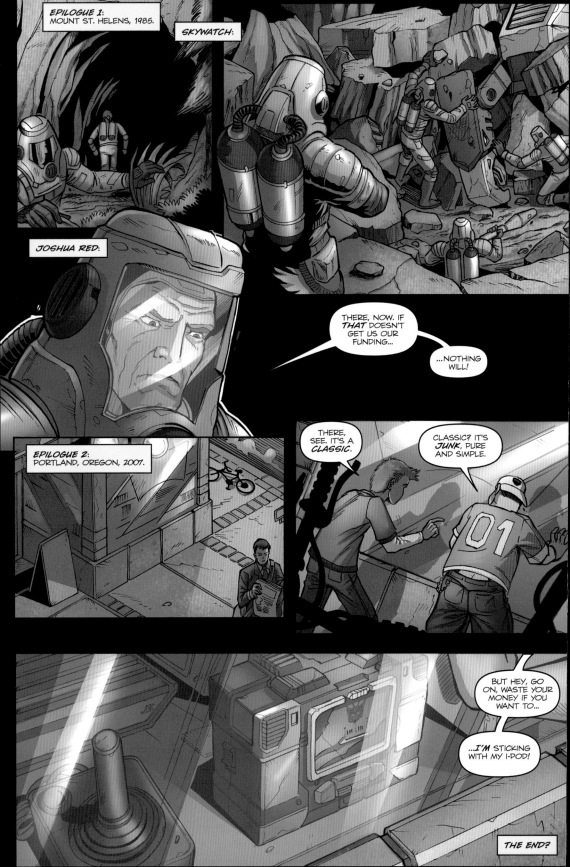

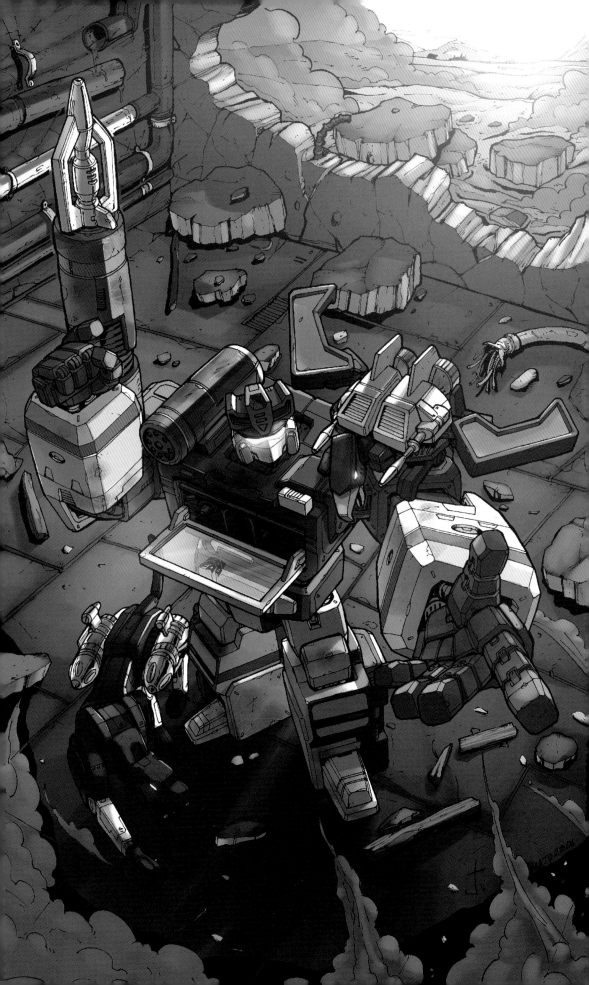

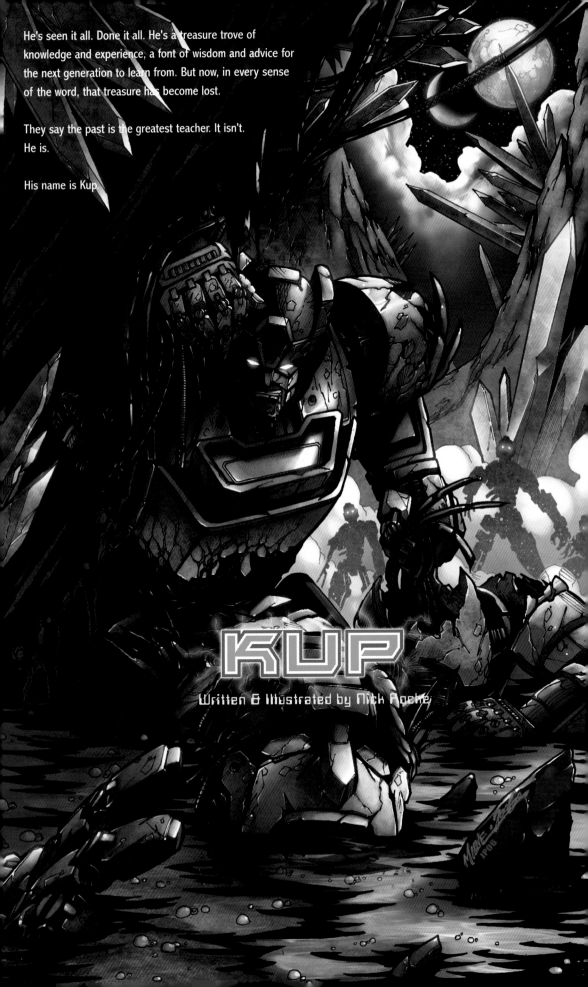

He's seen it all. Done it all. He's a treasure trove of
knowledge and experience, a font of wisdom and advice for
the next generation to learn from. But now, in every sense
of the word, that treasure has become lost.

They say the past is the greatest teacher. It isn't.
He is.

His name is Kup.

KUP

Written & Illustrated by Nick Roche

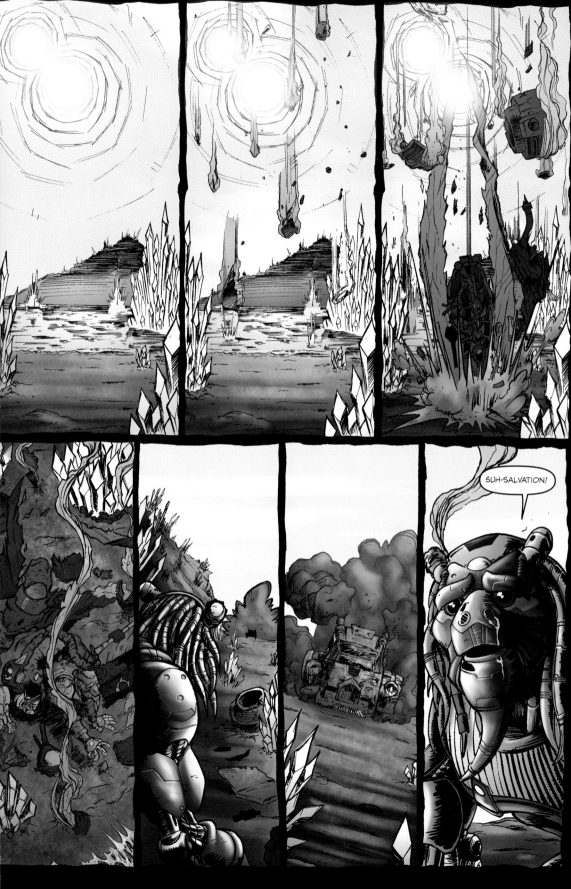

SUH-SALVATION!

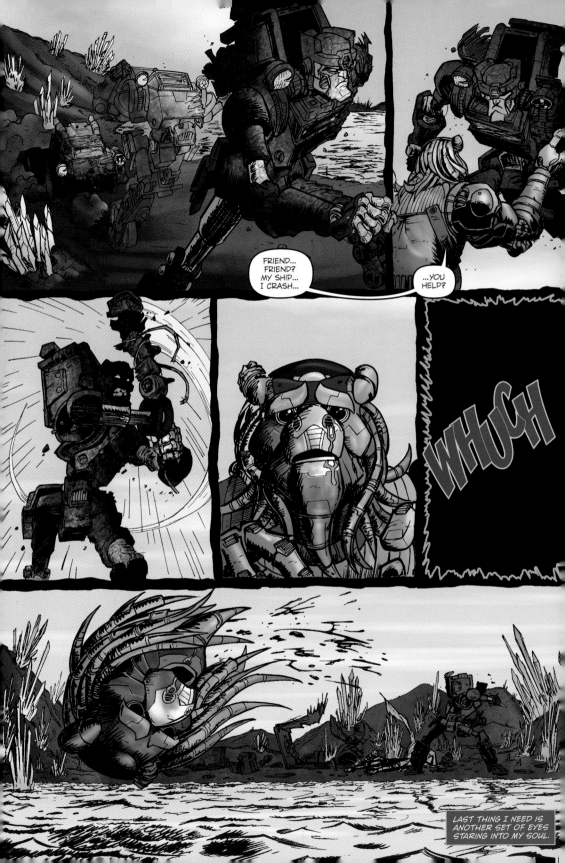

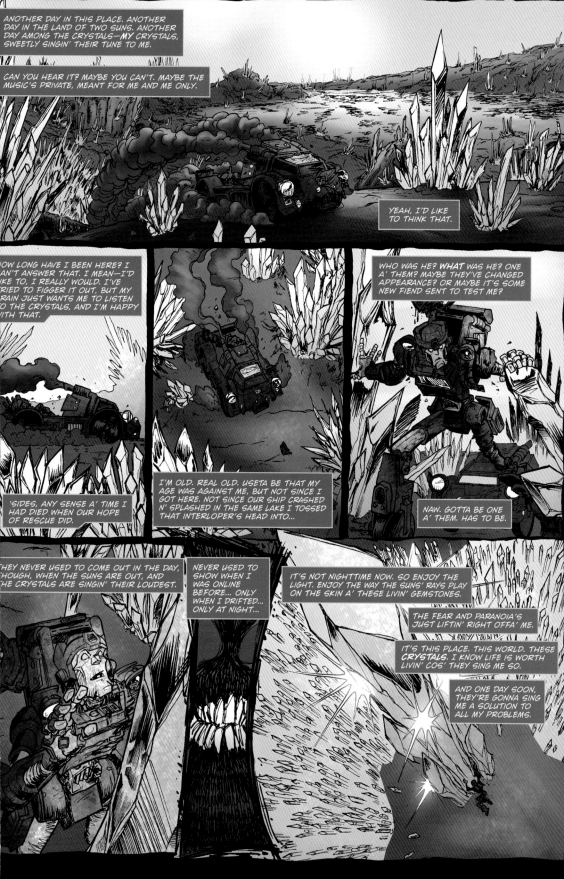

ANOTHER DAY IN THIS PLACE. ANOTHER DAY IN THE LAND OF TWO SUNS. ANOTHER DAY AMONG THE CRYSTALS—*MY* CRYSTALS, SWEETLY SINGIN' THEIR TUNE TO ME.

CAN YOU HEAR IT? MAYBE YOU CAN'T. MAYBE THE MUSIC'S PRIVATE, MEANT FOR ME AND ME ONLY.

YEAH, I'D LIKE TO THINK THAT.

HOW LONG HAVE I BEEN HERE? I CAN'T ANSWER THAT. I MEAN—I'D LIKE TO, I REALLY WOULD. I'VE TRIED TO FIGGER IT OUT, BUT MY BRAIN JUST WANTS ME TO LISTEN TO THE CRYSTALS, AND I'M HAPPY WITH THAT.

WHO WAS HE? *WHAT* WAS HE? ONE A' THEM? MAYBE THEY'VE CHANGED APPEARANCE? OR MAYBE IT'S SOME NEW FIEND SENT TO TEST ME?

'SIDES, ANY SENSE A' TIME I HAD DIED WHEN OUR HOPE OF RESCUE DID.

I'M OLD. REAL OLD. USETA BE THAT MY AGE WAS AGAINST ME, BUT NOT SINCE I GOT HERE. NOT SINCE OUR SHIP CRASHED N' SPLASHED IN THE SAME LAKE I TOSSED THAT INTERLOPER'S HEAD INTO...

NAW. GOTTA BE ONE A' THEM. HAS TO BE.

THEY NEVER USED TO COME OUT IN THE DAY, THOUGH, WHEN THE SUNS ARE OUT, AND THE CRYSTALS ARE SINGIN' THEIR LOUDEST.

NEVER USED TO SHOW WHEN I WAS ONLINE BEFORE... ONLY WHEN I DRIFTED... ONLY AT NIGHT...

IT'S NOT NIGHTTIME NOW. SO ENJOY THE LIGHT. ENJOY THE WAY THE SUNS' RAYS PLAY ON THE SKIN A' THESE LIVIN' GEMSTONES.

THE FEAR AND PARANOIA'S JUST LIFTIN' RIGHT OFFA' ME.

IT'S THIS PLACE. THIS WORLD. THESE *CRYSTALS*. I KNOW LIFE IS WORTH LIVIN' COS' THEY SING ME SO.

AND ONE DAY SOON, THEY'RE GONNA SING ME A SOLUTION TO ALL MY PROBLEMS.

31

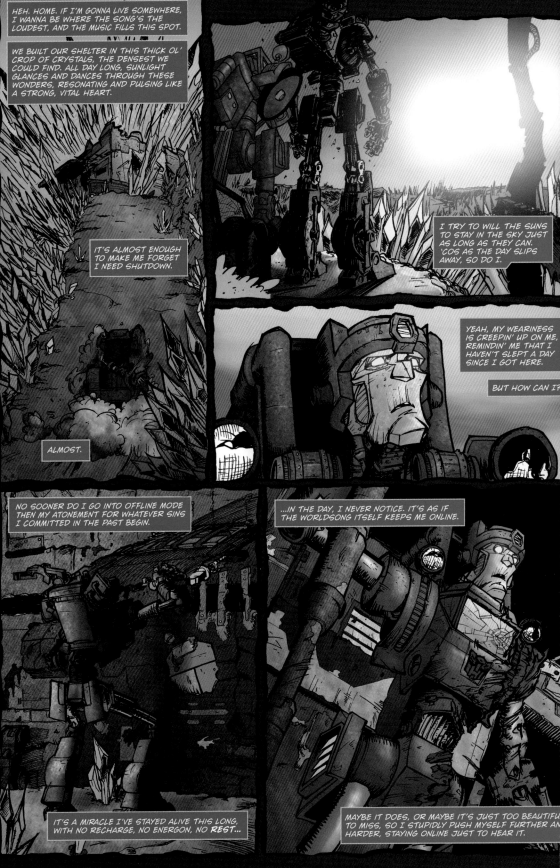

HEH. HOME. IF I'M GONNA LIVE SOMEWHERE, I WANNA BE WHERE THE SONG'S THE LOUDEST, AND THE MUSIC FILLS THIS SPOT.

WE BUILT OUR SHELTER IN THIS THICK OL' CROP OF CRYSTALS, THE DENSEST WE COULD FIND. ALL DAY LONG, SUNLIGHT GLANCES AND DANCES THROUGH THESE WONDERS, RESONATING AND PULSING LIKE A STRONG, VITAL HEART.

IT'S ALMOST ENOUGH TO MAKE ME FORGET I NEED SHUTDOWN.

I TRY TO WILL THE SUNS TO STAY IN THE SKY JUST AS LONG AS THEY CAN. 'COS AS THE DAY SLIPS AWAY, SO DO I.

ALMOST.

YEAH, MY WEARINESS IS CREEPIN' UP ON ME, REMINDIN' ME THAT I HAVEN'T SLEPT A DAY SINCE I GOT HERE.

BUT HOW CAN I?

NO SOONER DO I GO INTO OFFLINE MODE THEN MY ATONEMENT FOR WHATEVER SINS I COMMITTED IN THE PAST BEGIN.

...IN THE DAY, I NEVER NOTICE. IT'S AS IF THE WORLDSONG ITSELF KEEPS ME ONLINE.

IT'S A MIRACLE I'VE STAYED ALIVE THIS LONG, WITH NO RECHARGE, NO ENERGON, NO REST...

MAYBE IT DOES, OR MAYBE IT'S JUST TOO BEAUTIFUL TO MISS, SO I STUPIDLY PUSH MYSELF FURTHER AN HARDER, STAYING ONLINE JUST TO HEAR IT.

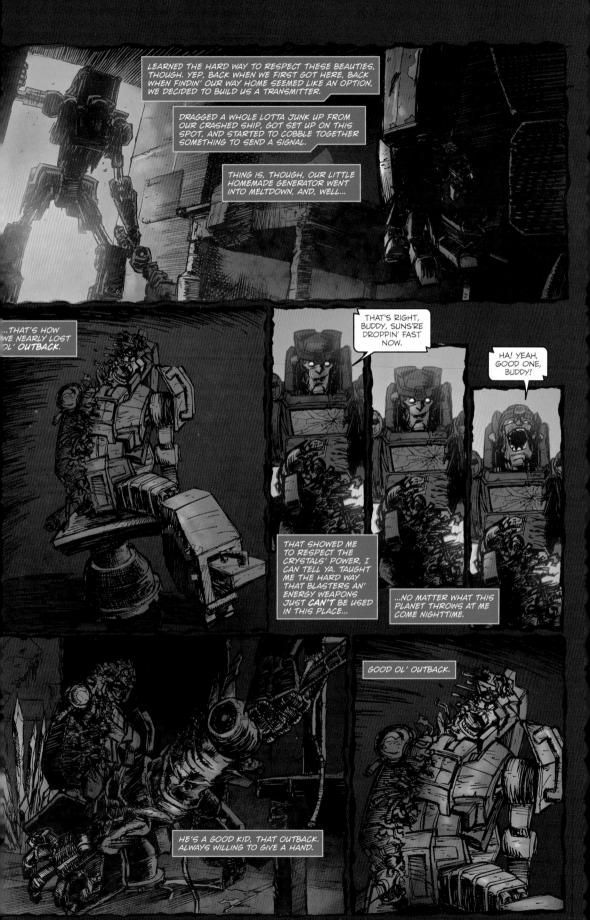

LEARNED THE HARD WAY TO RESPECT THESE BEAUTIES, THOUGH. YEP, BACK WHEN WE FIRST GOT HERE, BACK WHEN FINDIN' OUR WAY HOME SEEMED LIKE AN OPTION, WE DECIDED TO BUILD US A TRANSMITTER.

DRAGGED A WHOLE LOTTA JUNK UP FROM OUR CRASHED SHIP, GOT SET UP ON THIS SPOT, AND STARTED TO COBBLE TOGETHER SOMETHING TO SEND A SIGNAL.

THING IS, THOUGH, OUR LITTLE HOMEMADE GENERATOR WENT INTO MELTDOWN, AND, WELL...

...THAT'S HOW WE NEARLY LOST OL' OUTBACK.

THAT'S RIGHT, BUDDY, SUNS'RE DROPPIN' FAST NOW.

HA! YEAH, GOOD ONE, BUDDY!

THAT SHOWED ME TO RESPECT THE CRYSTALS' POWER, I CAN TELL YA. TAUGHT ME THE HARD WAY THAT BLASTERS AN' ENERGY WEAPONS JUST *CAN'T* BE USED IN THIS PLACE...

...NO MATTER WHAT THIS PLANET THROWS AT ME COME NIGHTTIME.

GOOD OL' OUTBACK.

HE'S A GOOD KID, THAT OUTBACK. ALWAYS WILLING TO GIVE A HAND.

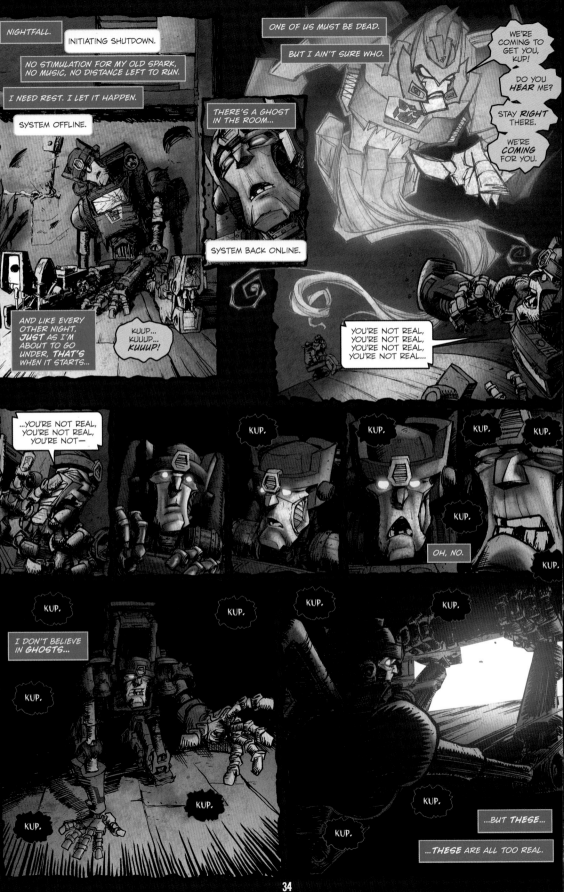

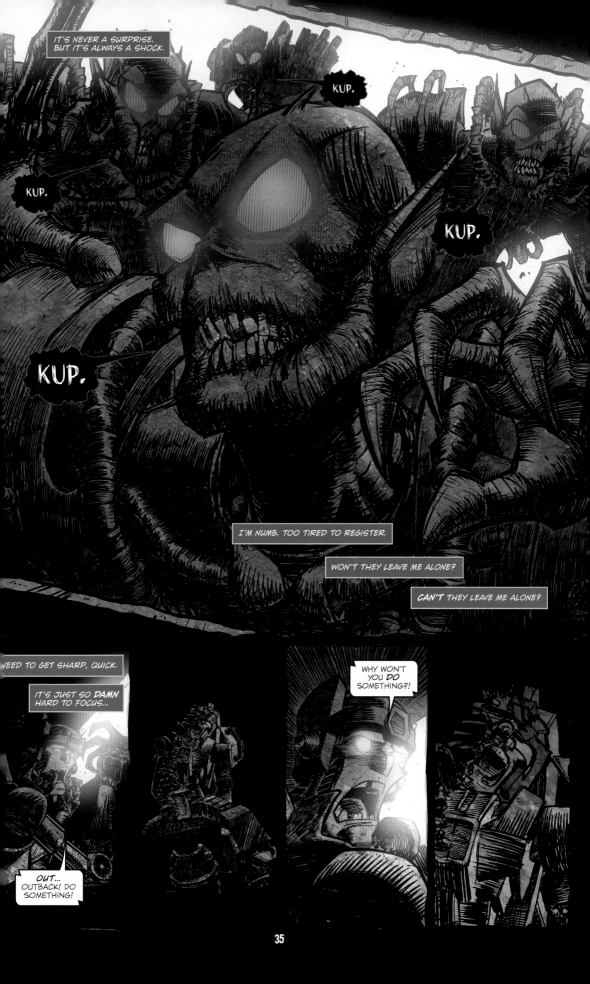

35

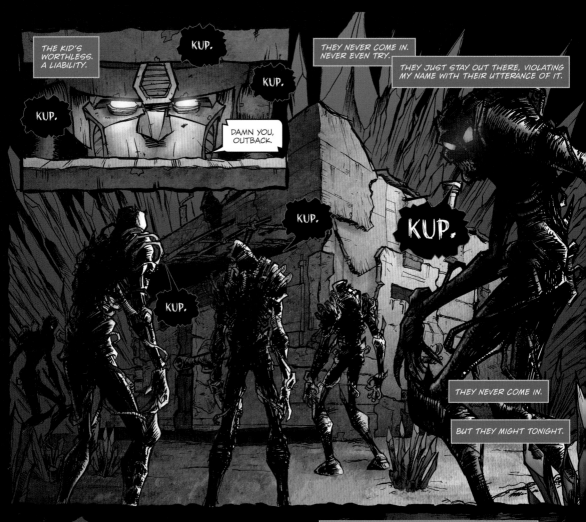
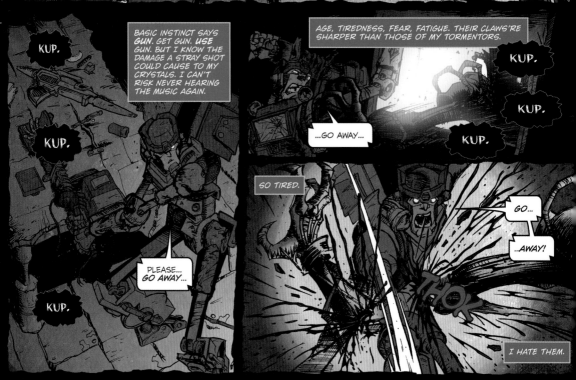

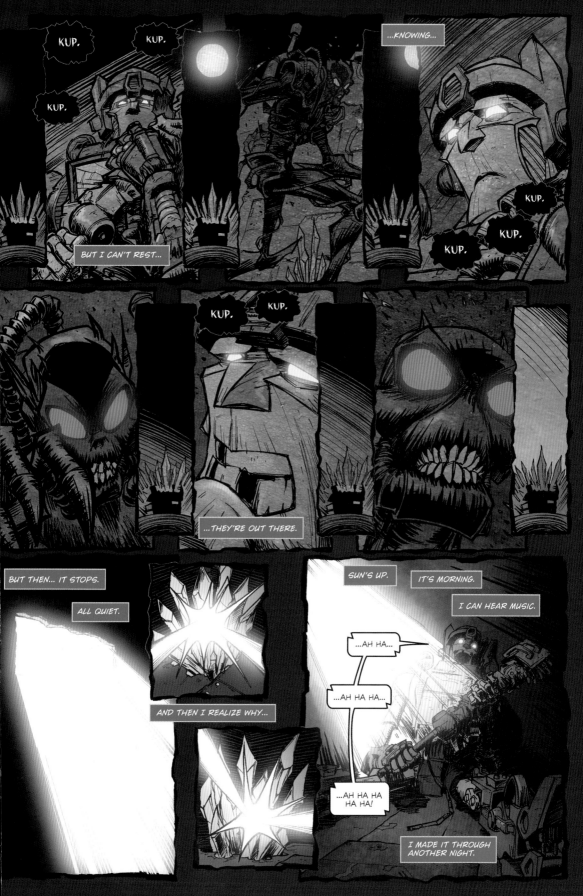

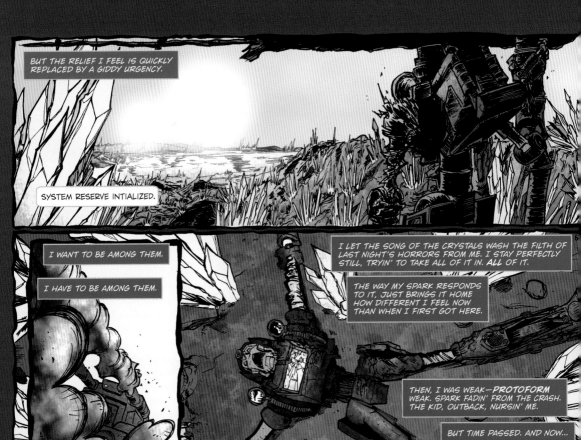

BUT THE RELIEF I FEEL IS QUICKLY REPLACED BY A GIDDY URGENCY.

SYSTEM RESERVE INTIALIZED.

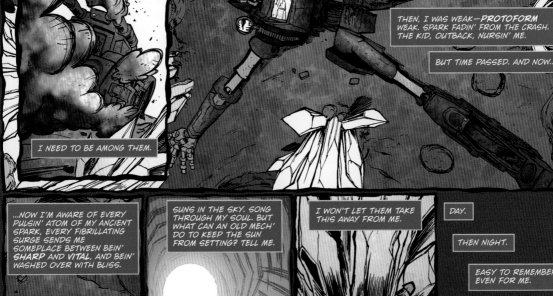

I WANT TO BE AMONG THEM.

I HAVE TO BE AMONG THEM.

I NEED TO BE AMONG THEM.

I LET THE SONG OF THE CRYSTALS WASH THE FILTH OF LAST NIGHT'S HORRORS FROM ME. I STAY PERFECTLY STILL, TRYIN' TO TAKE ALL OF IT IN. **ALL** OF IT.

THE WAY MY SPARK RESPONDS TO IT, JUST BRINGS IT HOME HOW DIFFERENT I FEEL NOW THAN WHEN I FIRST GOT HERE.

THEN, I WAS WEAK—**PROTOFORM** WEAK. SPARK FADIN' FROM THE CRASH. THE KID, OUTBACK, NURSIN' ME.

BUT TIME PASSED. AND NOW...

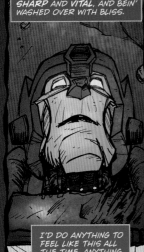

...NOW I'M AWARE OF EVERY PULSIN' ATOM OF MY ANCIENT SPARK, EVERY FIBRILLATING SURGE SENDS ME SOMEPLACE BETWEEN BEIN' **SHARP** AND **VITAL**, AND BEIN' WASHED OVER WITH BLISS.

I'D DO ANYTHING TO FEEL LIKE THIS ALL THE TIME. ANYTHING.

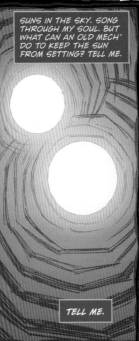

SUNS IN THE SKY. SONG THROUGH MY SOUL. BUT WHAT CAN AN OLD MECH' DO TO KEEP THE SUN FROM SETTING? TELL ME.

TELL ME.

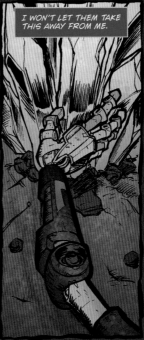

I WON'T LET THEM TAKE THIS AWAY FROM ME.

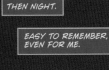

DAY.

THEN NIGHT.

EASY TO REMEMBER, EVEN FOR ME.

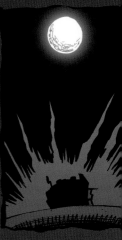

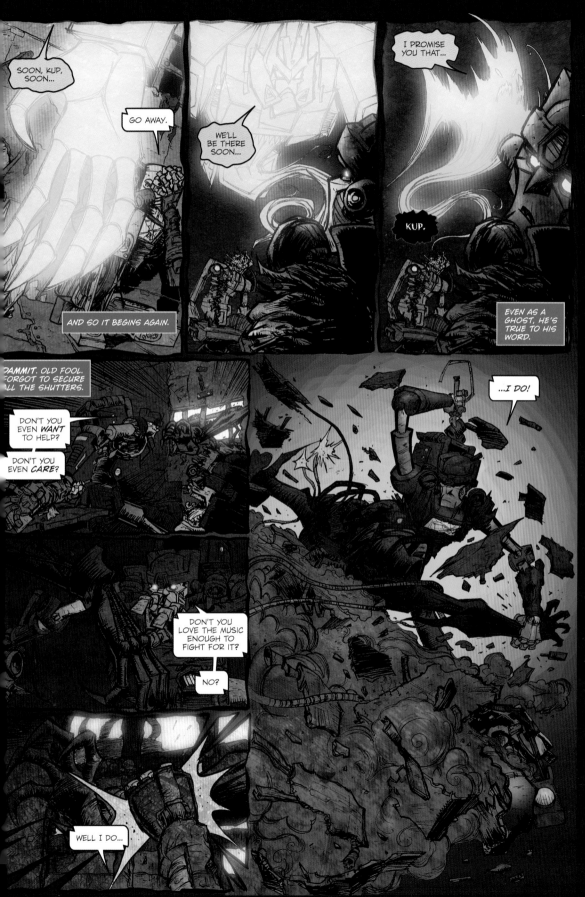

SOON, KUP, SOON...

GO AWAY.

WE'LL BE THERE SOON...

I PROMISE YOU THAT...

KUP.

AND SO IT BEGINS AGAIN.

EVEN AS A GHOST, HE'S TRUE TO HIS WORD.

DAMMIT. OLD FOOL. FORGOT TO SECURE ALL THE SHUTTERS.

DON'T YOU EVEN WANT TO HELP?

DON'T YOU EVEN CARE?

...I DO!

DON'T YOU LOVE THE MUSIC ENOUGH TO FIGHT FOR IT?

NO?

WELL I DO...

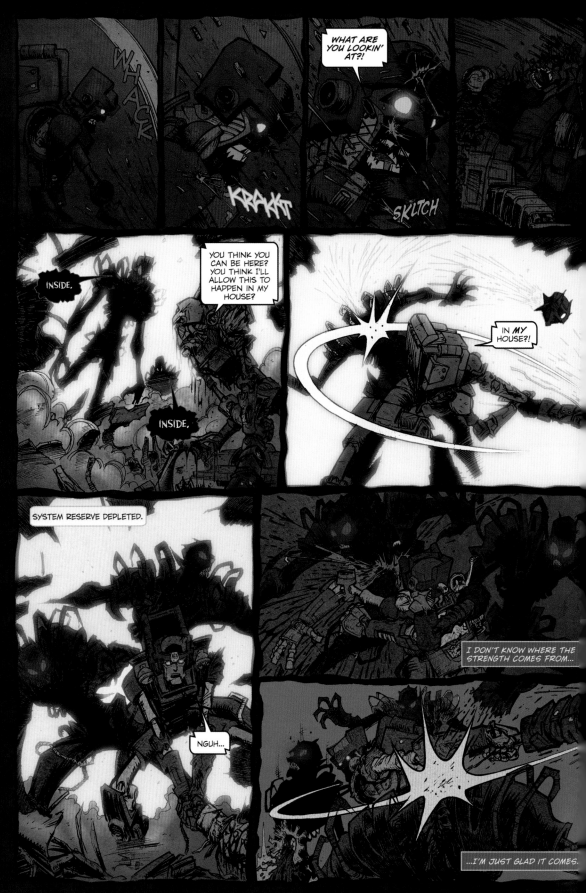

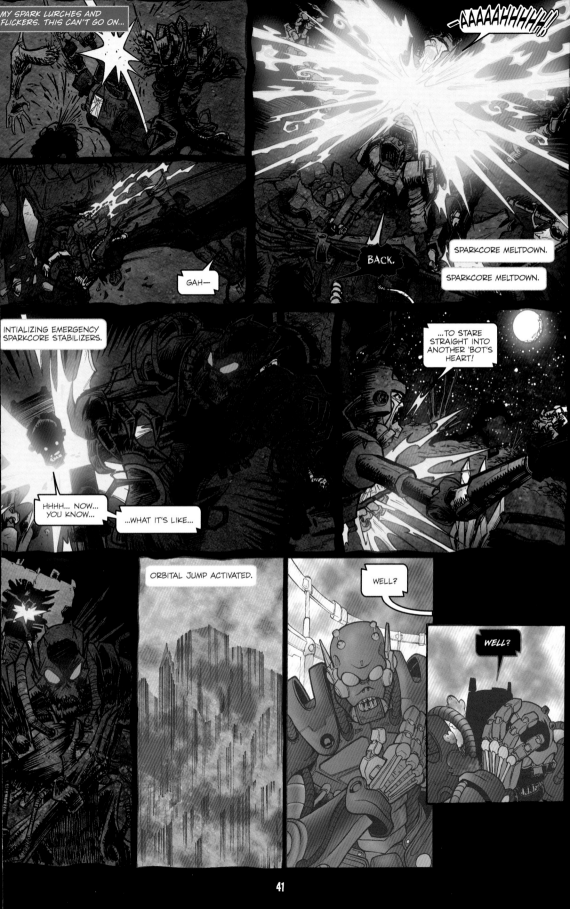

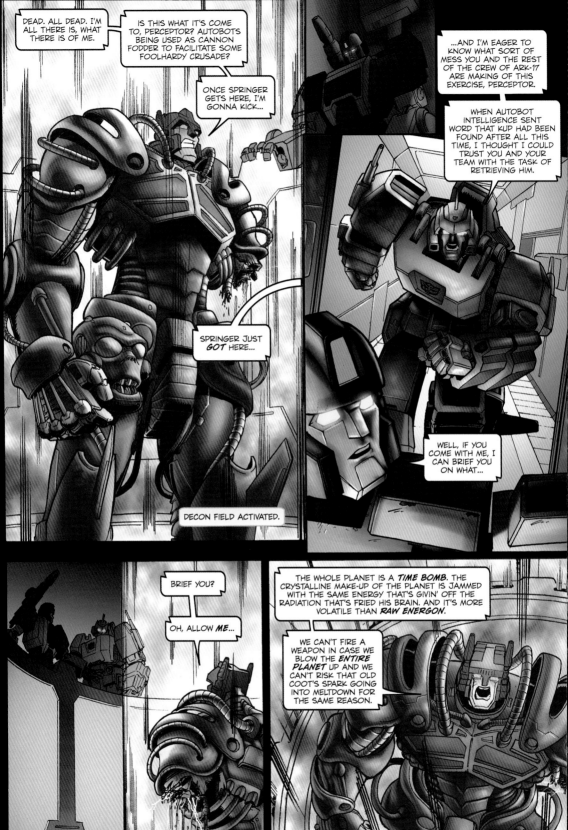

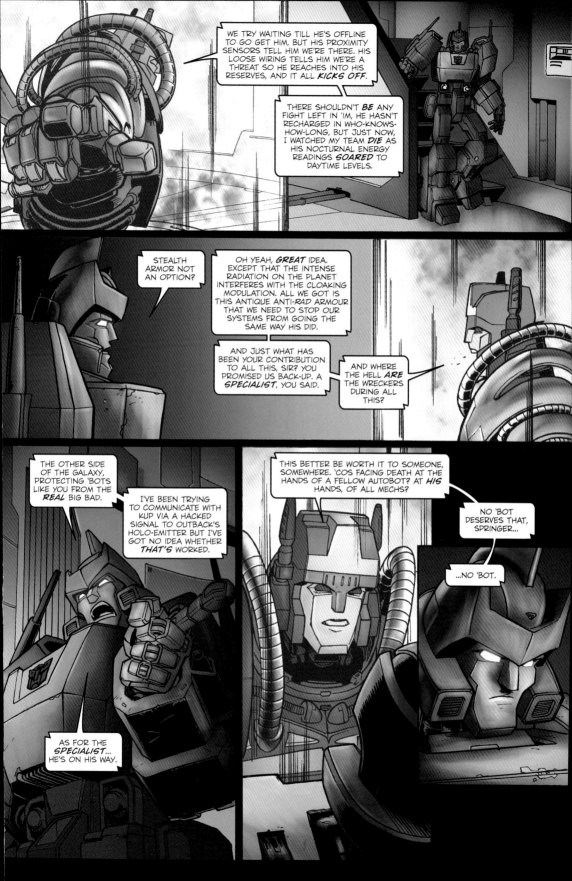

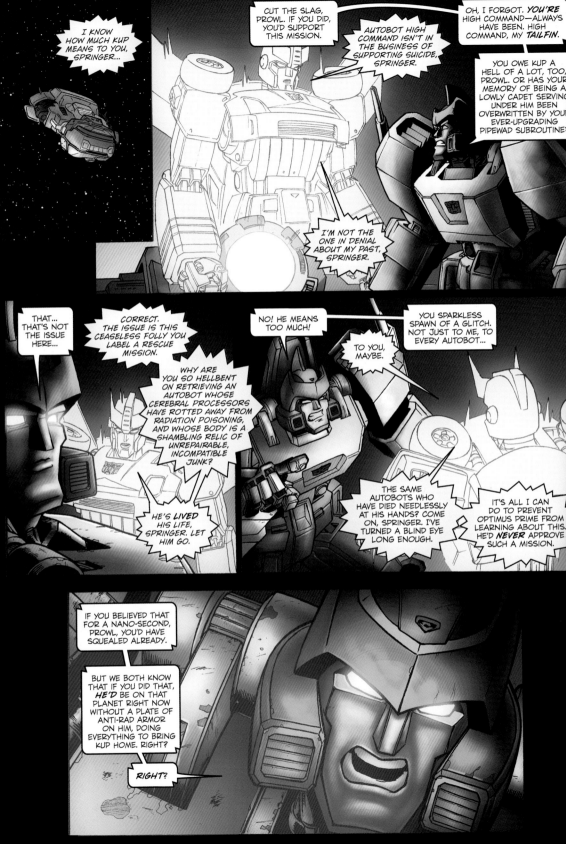

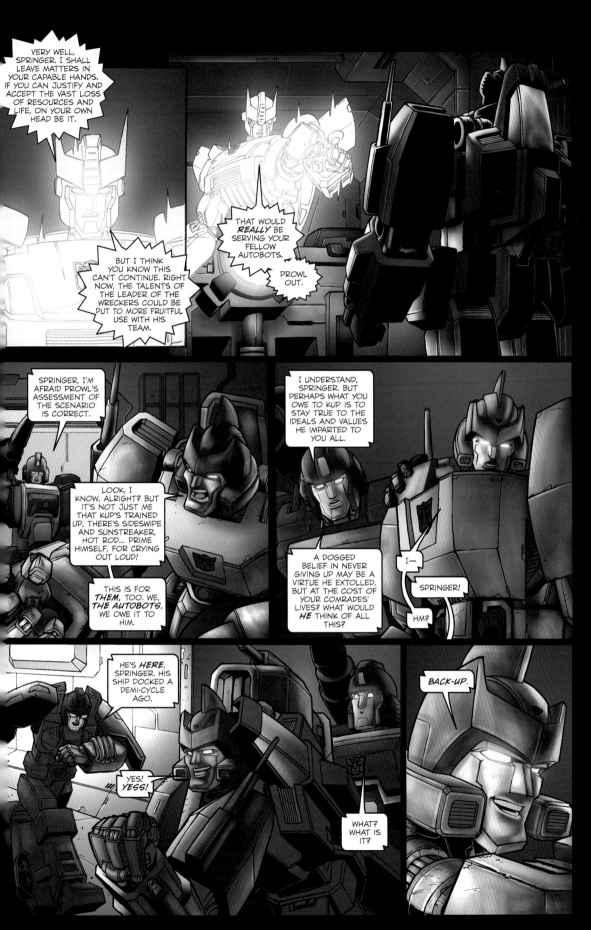



45

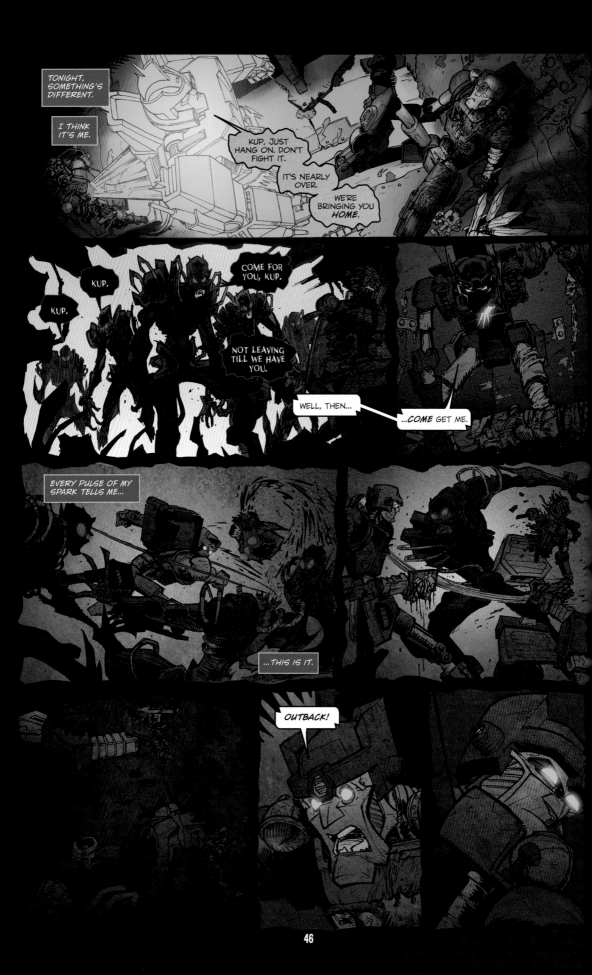

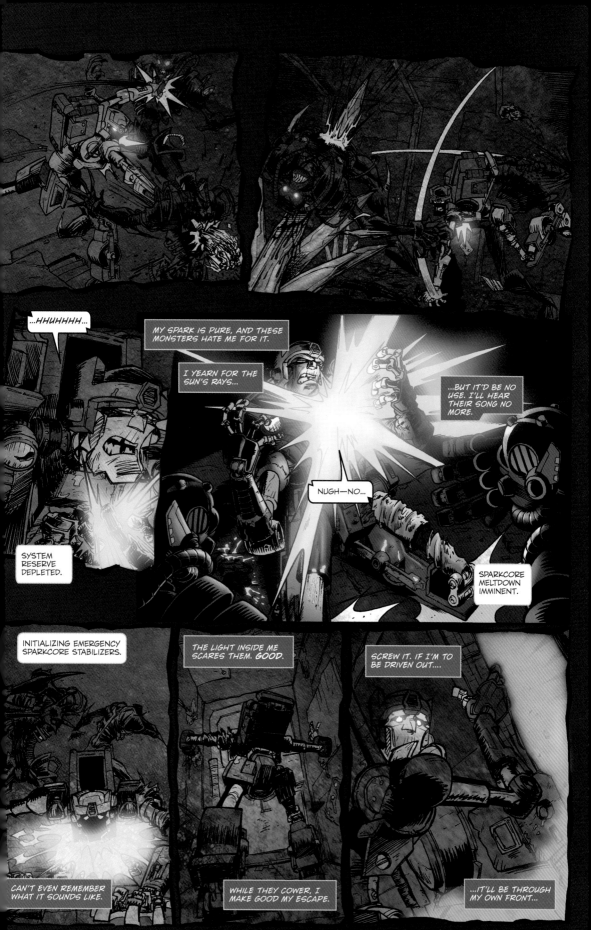

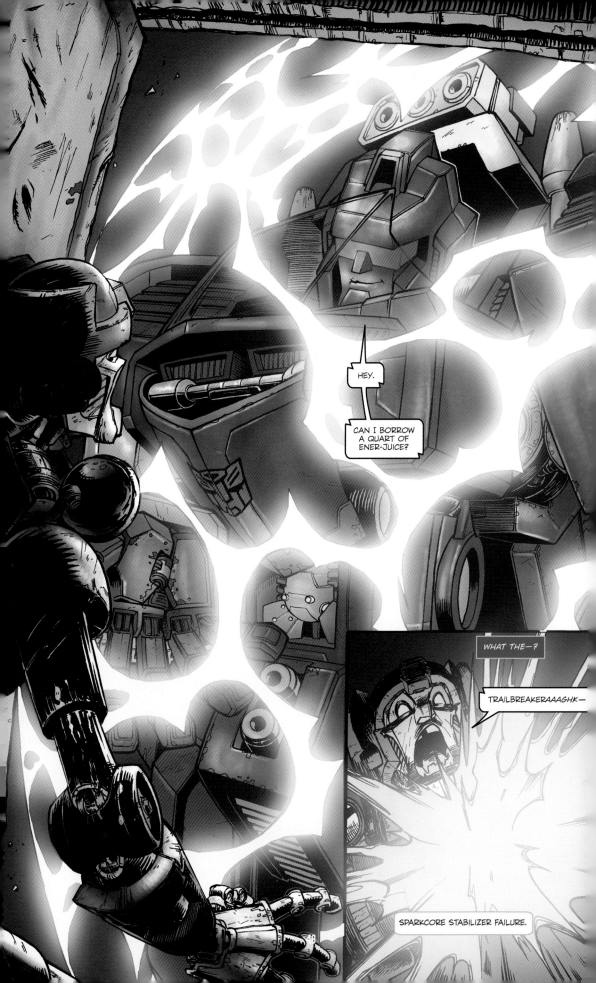

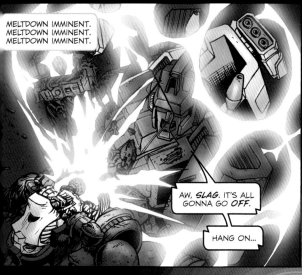

MELTDOWN IMMINENT.
MELTDOWN IMMINENT.
MELTDOWN IMMINENT.

AW, *SLAG.* IT'S ALL GONNA GO *OFF.*

HANG ON...

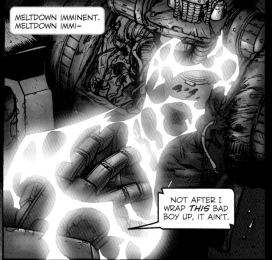

MELTDOWN IMMINENT.
MELTDOWN IMMI–

NOT AFTER I WRAP *THIS* BAD BOY UP, IT AIN'T.

WH MP

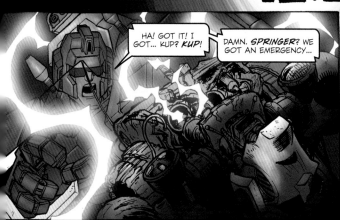

HA! GOT IT! I GOT... KUP? *KUP!*

DAMN. *SPRINGER?* WE GOT AN EMERGENCY...

ORBITAL JUMP ACTIVATED.

KUP.

KUP...

WE GOT YOU, OLD-TIMER...

...WE GOT YOU.

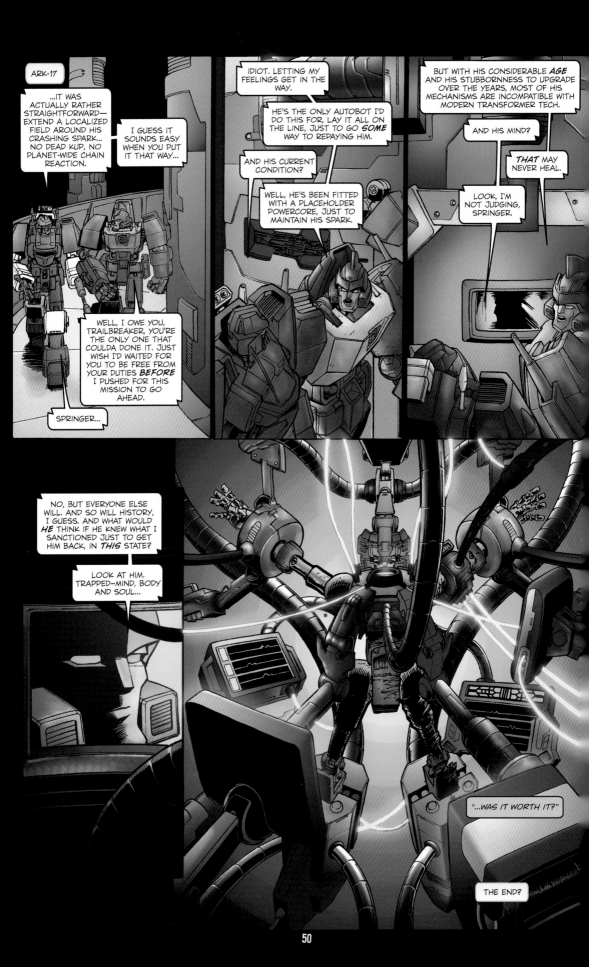

ARK-17

...IT WAS ACTUALLY RATHER STRAIGHTFORWARD— EXTEND A LOCALIZED FIELD AROUND HIS CRASHING SPARK... NO DEAD KUP, NO PLANET-WIDE CHAIN REACTION.

I GUESS IT SOUNDS EASY WHEN YOU PUT IT THAT WAY...

IDIOT. LETTING MY FEELINGS GET IN THE WAY.

HE'S THE ONLY AUTOBOT I'D DO THIS FOR, LAY IT ALL ON THE LINE, JUST TO GO *SOME* WAY TO REPAYING HIM.

AND HIS CURRENT CONDITION?

WELL, HE'S BEEN FITTED WITH A PLACEHOLDER POWERCORE, JUST TO MAINTAIN HIS SPARK.

BUT WITH HIS CONSIDERABLE *AGE* AND HIS STUBBORNNESS TO UPGRADE OVER THE YEARS, MOST OF HIS MECHANISMS ARE INCOMPATIBLE WITH MODERN TRANSFORMER TECH.

AND HIS MIND?

THAT MAY NEVER HEAL.

LOOK, I'M NOT JUDGING, SPRINGER.

WELL, I OWE YOU, TRAILBREAKER, YOU'RE THE ONLY ONE THAT COULDA DONE IT. JUST WISH I'D WAITED FOR YOU TO BE FREE FROM YOUR DUTIES *BEFORE* I PUSHED FOR THIS MISSION TO GO AHEAD.

SPRINGER...

NO, BUT EVERYONE ELSE WILL. AND SO WILL HISTORY, I GUESS. AND WHAT WOULD *HE* THINK IF HE KNEW WHAT I SANCTIONED JUST TO GET HIM BACK, IN *THIS* STATE?

LOOK AT HIM. TRAPPED—MIND, BODY AND SOUL...

"...WAS IT WORTH IT?"

THE END?

50

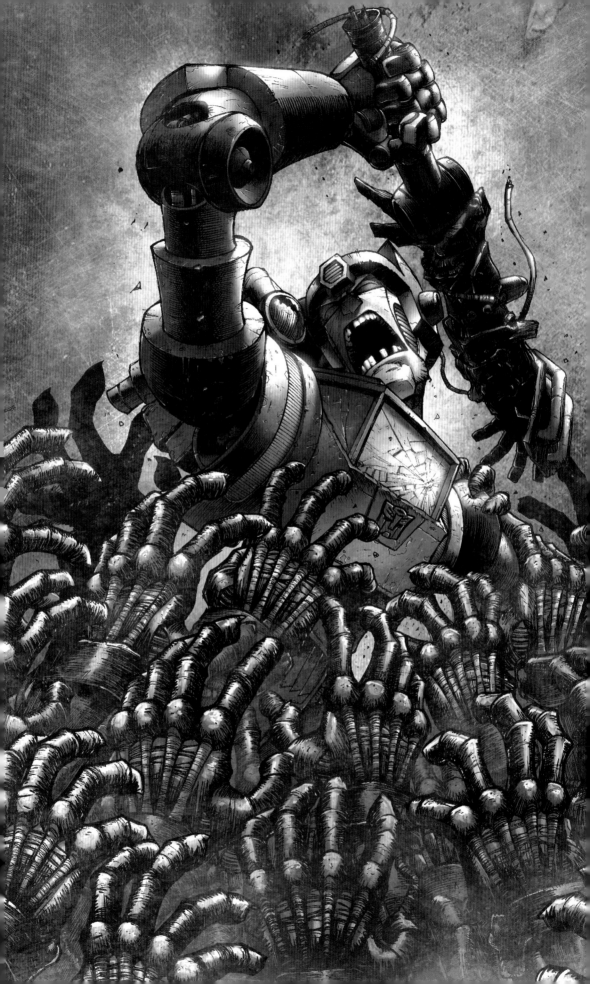

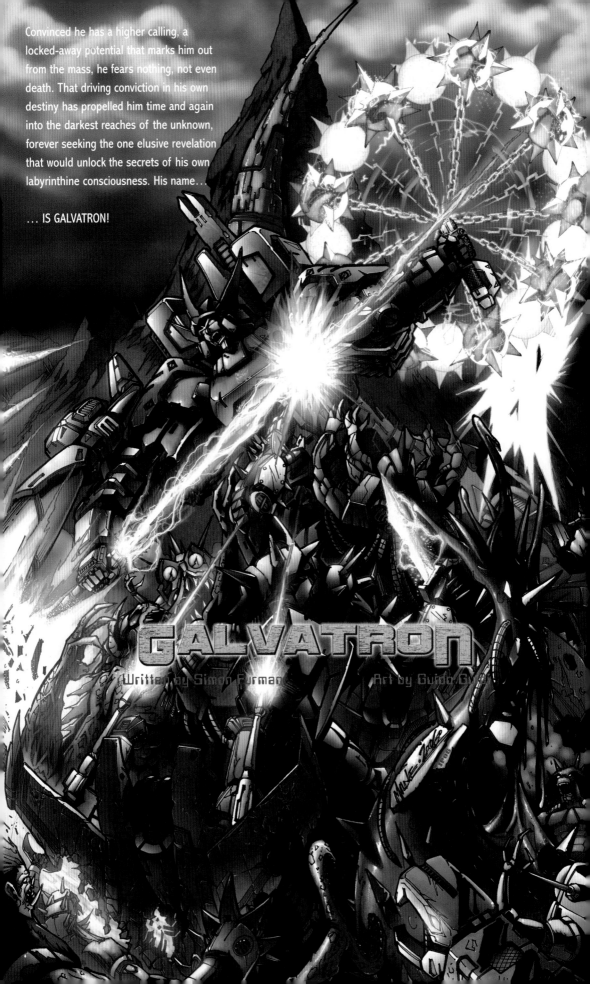

Convinced he has a higher calling, a locked-away potential that marks him out from the mass, he fears nothing, not even death. That driving conviction in his own destiny has propelled him time and again into the darkest reaches of the unknown, forever seeking the one elusive revelation that would unlock the secrets of his own labyrinthine consciousness. His name...

... IS GALVATRON!

GALVATRON

Written by Simon Furman Art by Guido Guidi

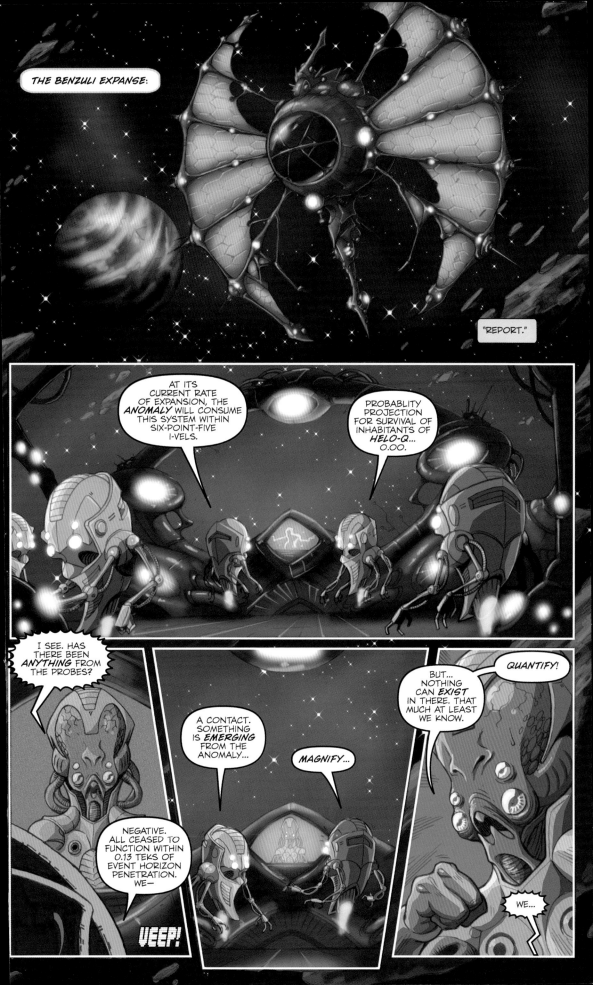

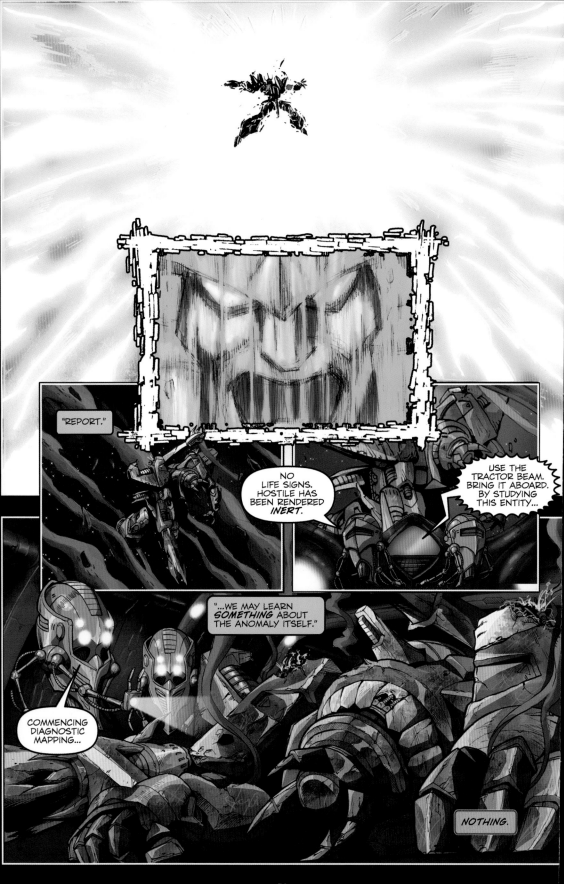

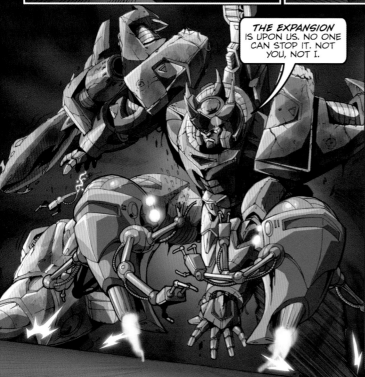

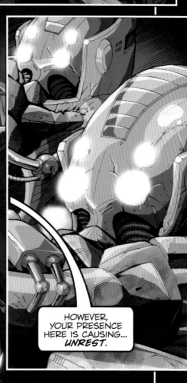

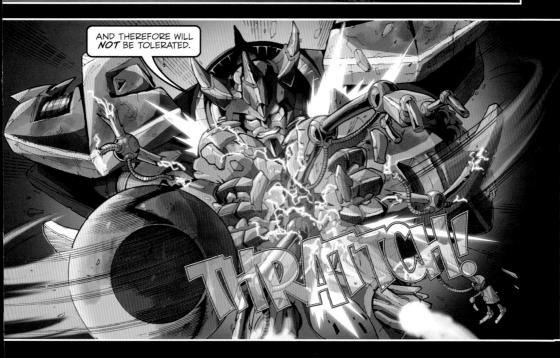

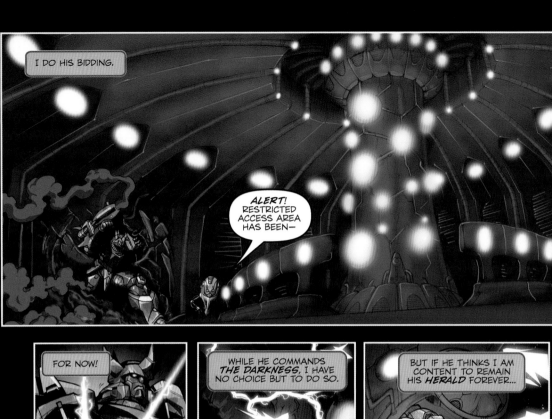

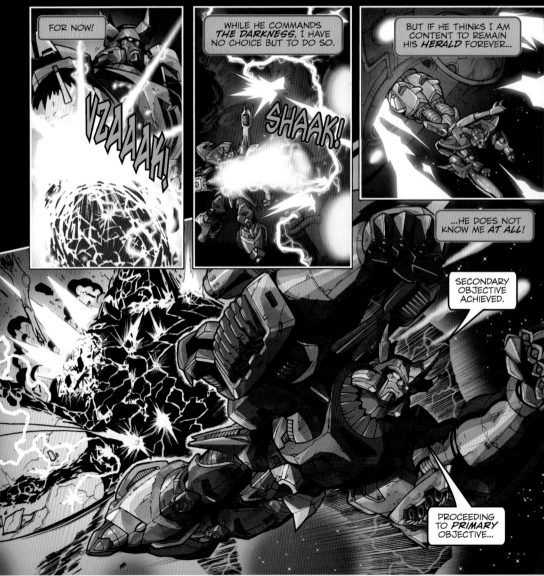

CYBERTRON.

THUNDERHEAD PASS:

"FACE IT, *LEADFOOT*, THIS IS A *NOWHERE* POSTING..."

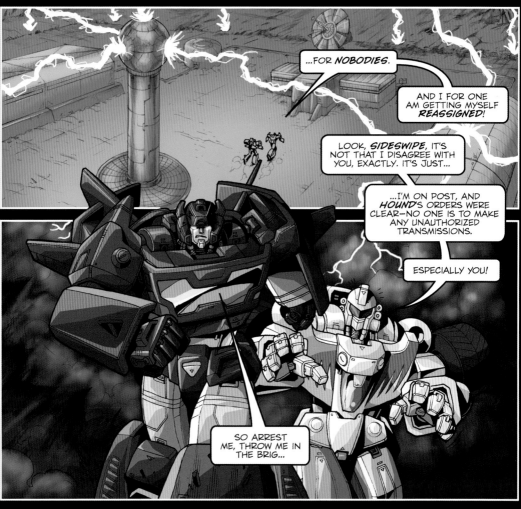

...FOR *NOBODIES*.

AND I FOR ONE AM GETTING MYSELF *REASSIGNED!*

LOOK, *SIDESWIPE*, IT'S NOT THAT I DISAGREE WITH YOU, EXACTLY. IT'S JUST...

...I'M ON POST, AND *HOUND'S* ORDERS WERE CLEAR—NO ONE IS TO MAKE ANY UNAUTHORIZED TRANSMISSIONS.

ESPECIALLY YOU!

SO ARREST ME, THROW ME IN THE BRIG...

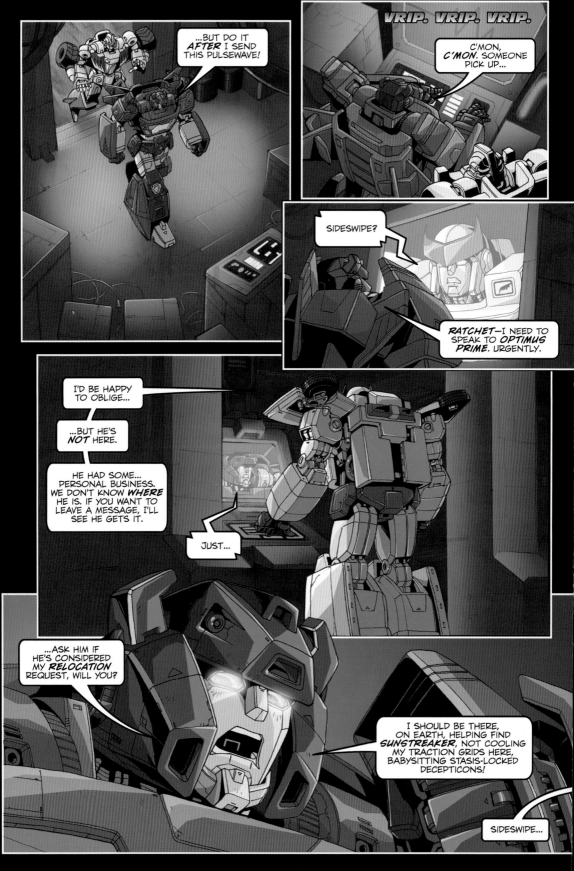

...BUT DO IT *AFTER* I SEND THIS PULSEWAVE!

VRIP. VRIP. VRIP.

C'MON, *C'MON.* SOMEONE PICK UP...

SIDESWIPE?

RATCHET—I NEED TO SPEAK TO *OPTIMUS PRIME.* URGENTLY.

I'D BE HAPPY TO OBLIGE...

...BUT HE'S *NOT* HERE.

HE HAD SOME... PERSONAL BUSINESS. WE DON'T KNOW *WHERE* HE IS. IF YOU WANT TO LEAVE A MESSAGE, I'LL SEE HE GETS IT.

JUST...

...ASK HIM IF HE'S CONSIDERED MY *RELOCATION* REQUEST, WILL YOU?

I SHOULD BE THERE, ON EARTH, HELPING FIND *SUNSTREAKER,* NOT COOLING MY TRACTION GRIDS HERE, BABYSITTING STASIS-LOCKED DECEPTICONS!

SIDESWIPE...

60

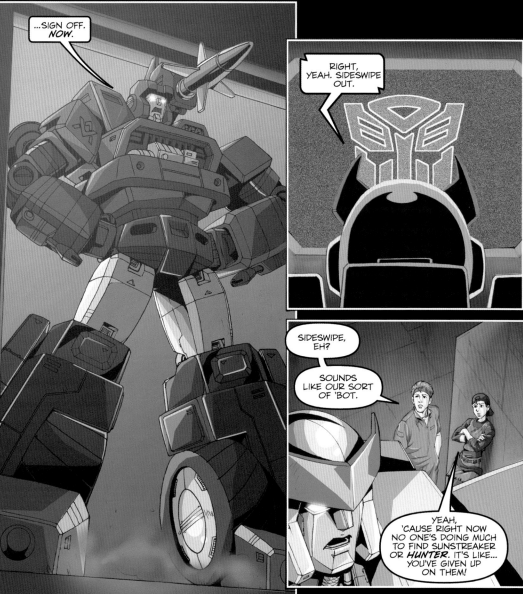

...SIGN OFF. *NOW.*

RIGHT, YEAH. SIDESWIPE OUT.

SIDESWIPE, EH?

SOUNDS LIKE OUR SORT OF 'BOT.

YEAH, 'CAUSE RIGHT NOW NO ONE'S DOING MUCH TO FIND SUNSTREAKER OR *HUNTER.* IT'S LIKE... YOU'VE GIVEN UP ON THEM!

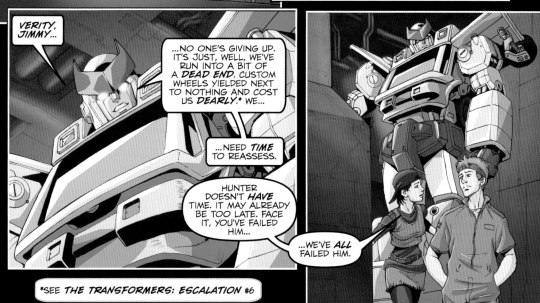

VERITY, JIMMY...

...NO ONE'S GIVING UP. IT'S JUST, WELL, WE'VE RUN INTO A BIT OF A *DEAD END.* CUSTOM WHEELS YIELDED NEXT TO NOTHING AND COST US *DEARLY.** WE...

...NEED *TIME* TO REASSESS.

HUNTER DOESN'T *HAVE* TIME. IT MAY ALREADY BE TOO LATE. FACE IT, YOU'VE FAILED HIM...

...WE'VE *ALL* FAILED HIM.

*SEE *THE TRANSFORMERS: ESCALATION* #6

61

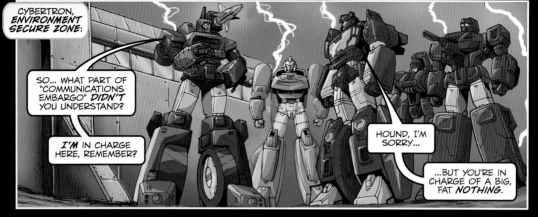

CYBERTRON, **ENVIRONMENT SECURE ZONE:**

SO... WHAT PART OF "COMMUNICATIONS EMBARGO" *DIDN'T* YOU UNDERSTAND?

I'M IN CHARGE HERE, REMEMBER?

HOUND, I'M SORRY...

...BUT YOU'RE IN CHARGE OF A BIG, FAT *NOTHING*.

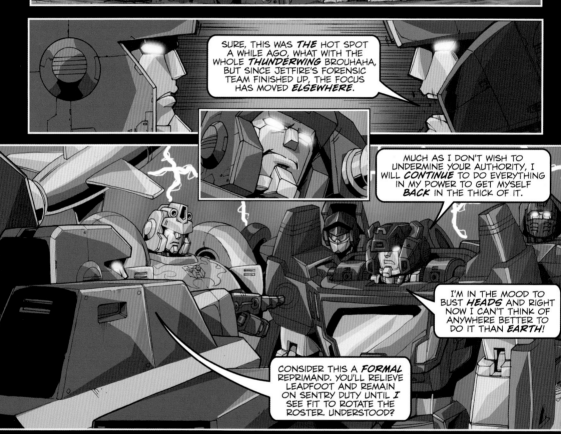

SURE, THIS WAS *THE* HOT SPOT A WHILE AGO, WHAT WITH THE WHOLE *THUNDERWING* BROUHAHA, BUT SINCE JETFIRE'S FORENSIC TEAM FINISHED UP, THE FOCUS HAS MOVED *ELSEWHERE*.

MUCH AS I DON'T WISH TO UNDERMINE YOUR AUTHORITY, I WILL *CONTINUE* TO DO EVERYTHING IN MY POWER TO GET MYSELF *BACK* IN THE THICK OF IT.

I'M IN THE MOOD TO BUST *HEADS* AND RIGHT NOW I CAN'T THINK OF ANYWHERE BETTER TO DO IT THAN *EARTH!*

CONSIDER THIS A *FORMAL* REPRIMAND. YOU'LL RELIEVE LEADFOOT AND REMAIN ON SENTRY DUTY UNTIL *I* SEE FIT TO ROTATE THE ROSTER. UNDERSTOOD?

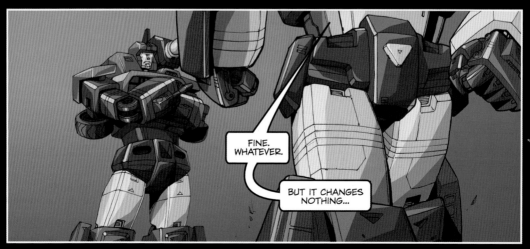

FINE. WHATEVER.

BUT IT CHANGES NOTHING...

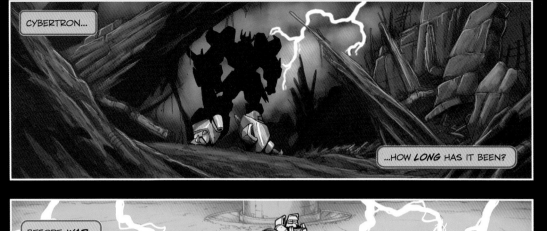

CYBERTRON...

...HOW *LONG* HAS IT BEEN?

BEFORE *WAR*...

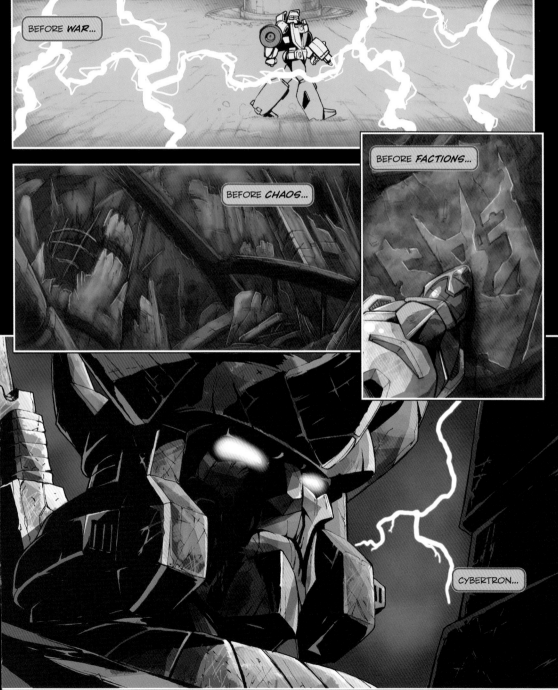

BEFORE *CHAOS*...

BEFORE *FACTIONS*...

CYBERTRON...

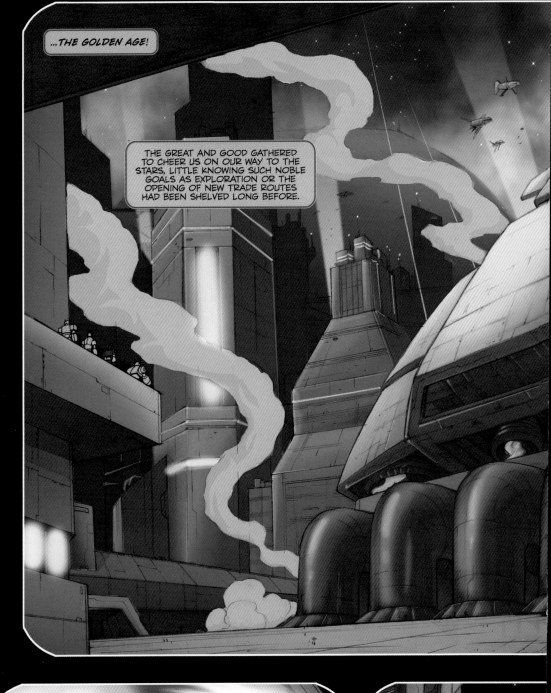

...THE GOLDEN AGE!

THE GREAT AND GOOD GATHERED TO CHEER US ON OUR WAY TO THE STARS, LITTLE KNOWING SUCH NOBLE GOALS AS EXPLORATION OR THE OPENING OF NEW TRADE ROUTES HAD BEEN SHELVED LONG BEFORE.

IT WAS, HE DESCRIBED...

FWUUMM!

..."LIKE A *DOOR* OPENING."

A DOOR TO SOMEWHERE ELSE. AND WITHIN...

...ABSOLUTE POWER!

THE ARK WAS ABOUT DESTINY!

PRIME FELT IT FIRST, A RESONANT TUG FROM SOMEWHERE DEEP WITHIN *THE MATRIX* HE CARRIED.

A BOTTOMLESS WELL, A DARK *MIRROR* OF THE MATRIX ITSELF—THE MEANS TO REMAKE THE ENTIRE UNIVERSE.

BUT THE VENTURE...

...WAS TO END IN *FAILURE*.

ALL EFFORTS TO PROBE THE YAWNING *NOTHINGNESS* THAT DOMINATED THE BENZULI EXPANSE PROVED FUTILE.

WE HAD COME SO FAR, RISKED SO MUCH... AND YET, SEEMINGLY, THE ANSWERS WE SOUGHT WERE AS *DISTANT* AS WHEN WE HAD SET OUT.

SOMEHOW, THOUGH, I SENSED THAT IT WAS THERE, THE KEY THAT WOULD FINALLY *UNLOCK* THE POTENTIAL I'D ALWAYS KNOWN LAY WITHIN ME.

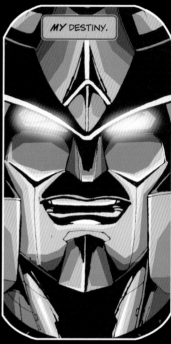

MY DESTINY.

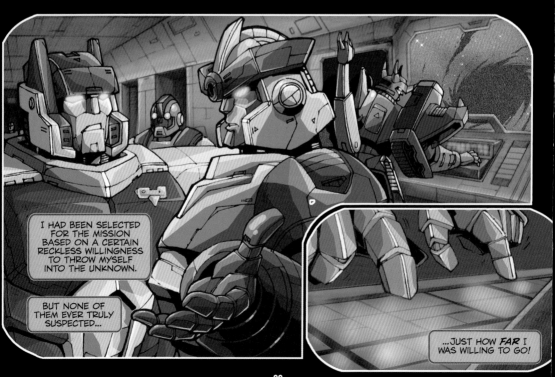

I HAD BEEN SELECTED FOR THE MISSION BASED ON A CERTAIN RECKLESS WILLINGNESS TO THROW MYSELF INTO THE UNKNOWN.

BUT NONE OF THEM EVER TRULY SUSPECTED...

...JUST HOW *FAR* I WAS WILLING TO GO!

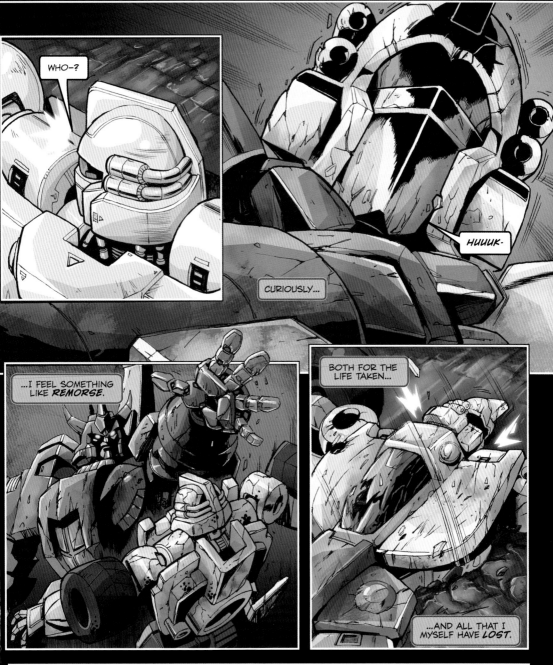

WHO-?

HUUUK-

CURIOUSLY...

...I FEEL SOMETHING LIKE *REMORSE*.

BOTH FOR THE LIFE TAKEN...

...AND ALL THAT I MYSELF HAVE *LOST*.

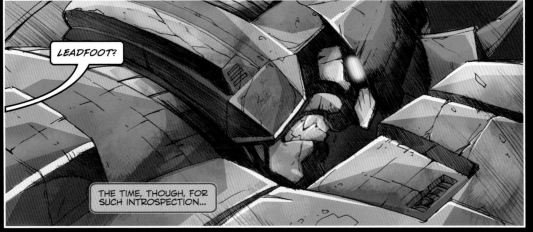

LEADFOOT?

THE TIME, THOUGH, FOR SUCH INTROSPECTION...

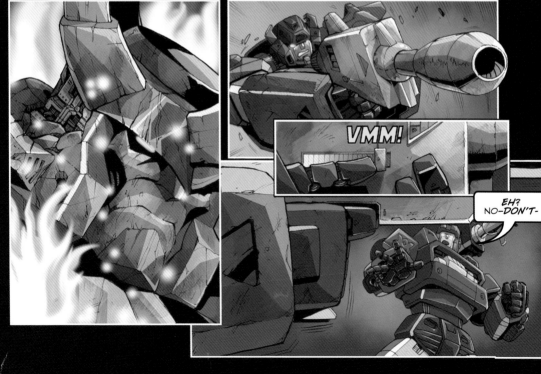

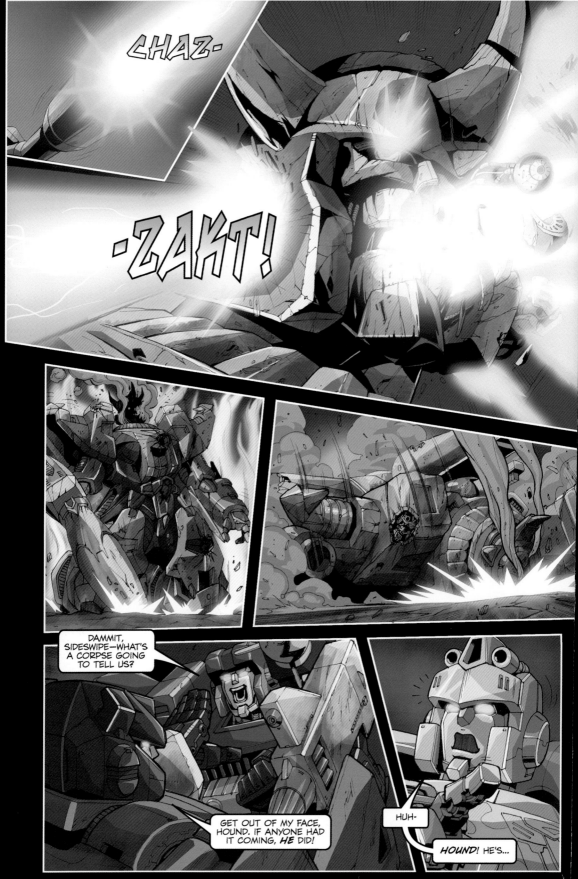

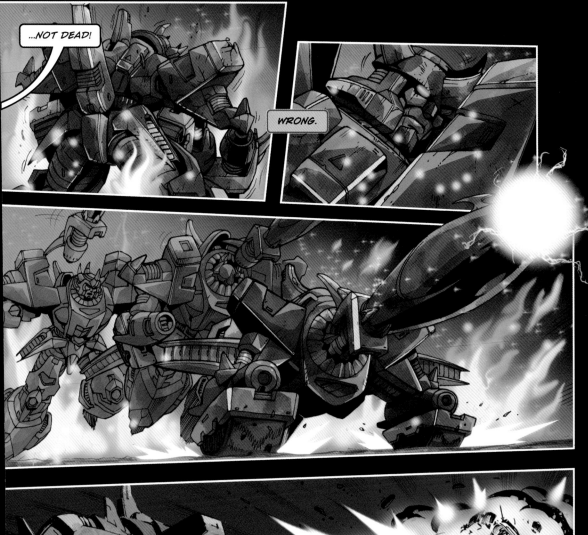

...NOT DEAD!

WRONG.

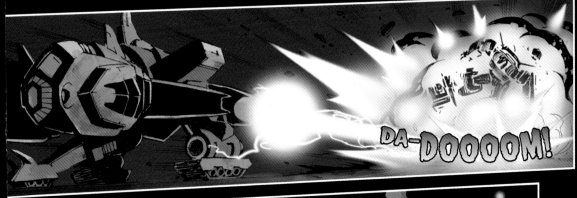

DA-DOOOOM!

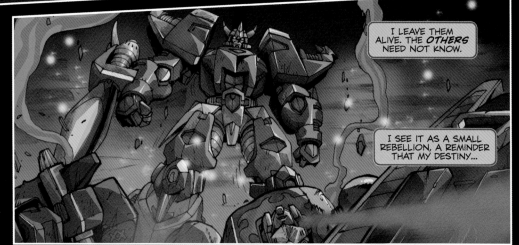

I LEAVE THEM ALIVE. THE *OTHERS* NEED NOT KNOW.

I SEE IT AS A SMALL REBELLION, A REMINDER THAT MY DESTINY...

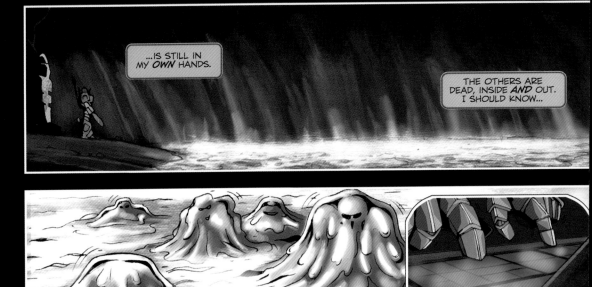

...IS STILL IN MY *OWN* HANDS.

THE OTHERS ARE DEAD, INSIDE *AND* OUT. I SHOULD KNOW...

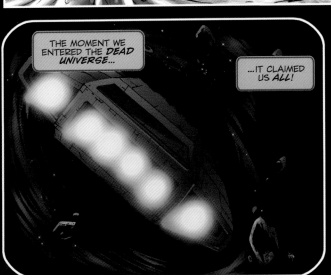

I KILLED THEM.

THE MOMENT WE ENTERED THE *DEAD UNIVERSE*...

...IT CLAIMED US *ALL!*

...I REPEAT, THIS IS AN *EMERGENCY*, WE—

HOUND! IT'S *GONE!*

WH-? WHAT'S GONE? *WHAT?*

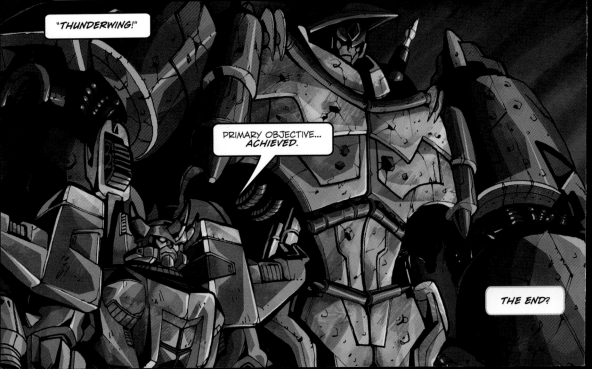

"*THUNDERWING!*"

PRIMARY OBJECTIVE... *ACHIEVED.*

THE END?

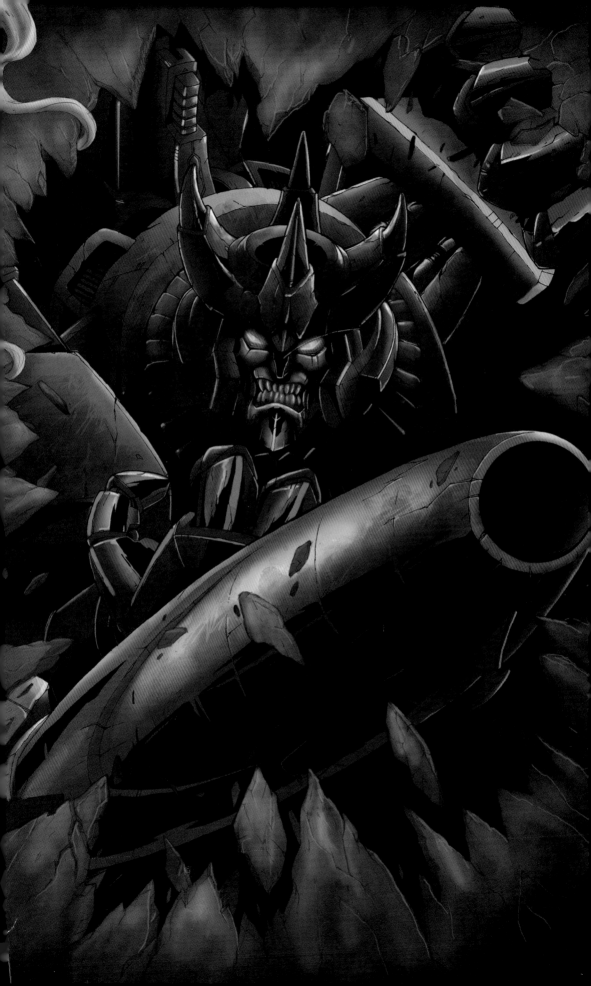

He is the ultimate authority, the figurehead of an entire race.
He stands for integrity, virtue and honor, his title representing
a single-minded commitment to safeguard life and liberty
throughout the universe. He stands apart, aloof, an island,
encapsulating an ideal and an archetype. He understands he
must be 'more' than his fellow CYBERTRONIANS, inviolate and
incorruptible. But scratch the surface, and PRIME is just a
mortal being, steel and sinew, as were those who came
before...

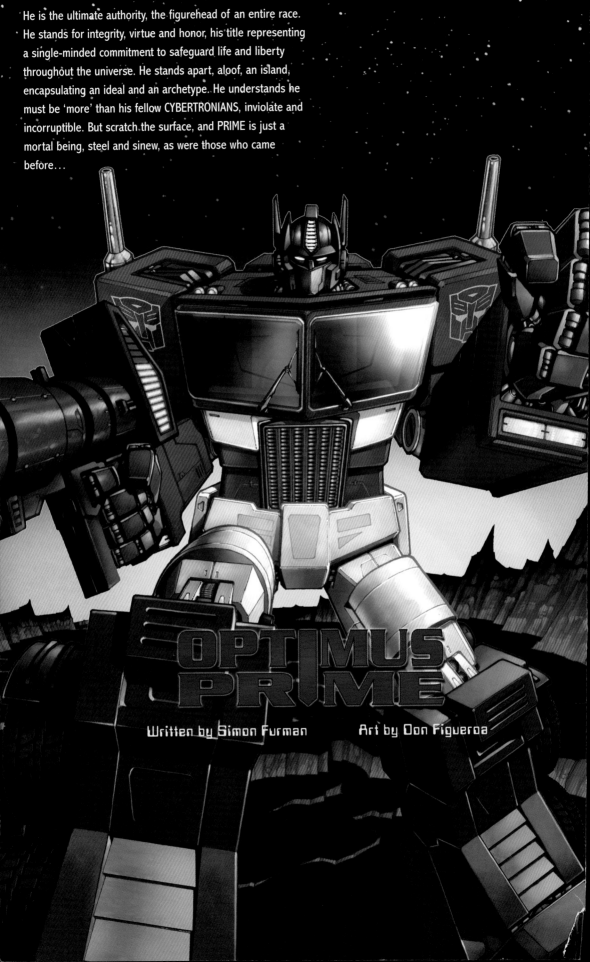

OPTIMUS PRIME

Written by Simon Furman Art by Don Figueroa

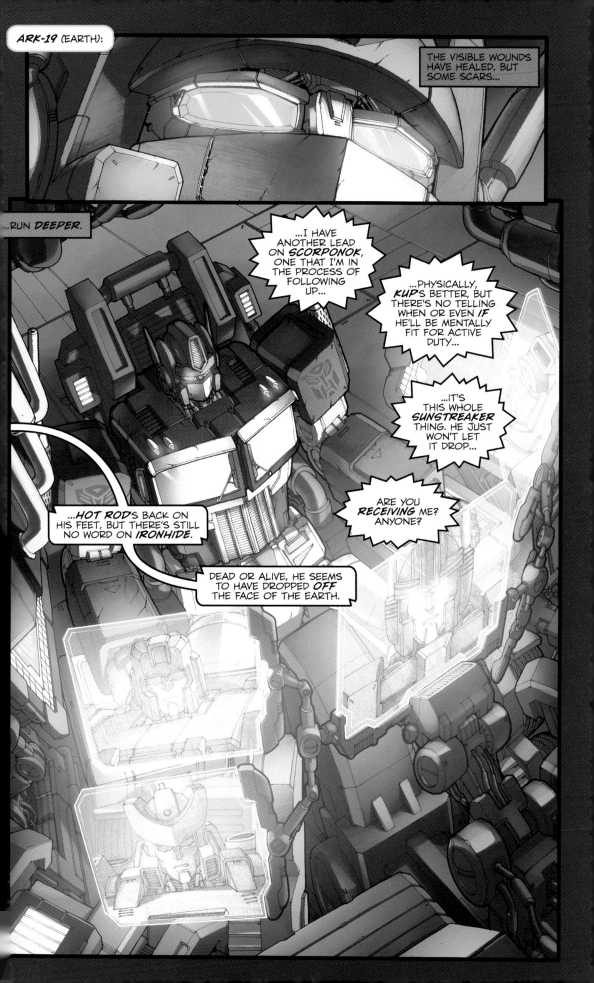

THE VISIBLE WOUNDS HAVE HEALED, BUT SOME SCARS...

..RUN *DEEPER*.

...I HAVE ANOTHER LEAD ON *SCORPONOK*, ONE THAT I'M IN THE PROCESS OF FOLLOWING UP...

...PHYSICALLY, *KUP'S* BETTER, BUT THERE'S NO TELLING WHEN OR EVEN *IF* HE'LL BE MENTALLY FIT FOR ACTIVE DUTY...

...IT'S THIS WHOLE *SUNSTREAKER* THING. HE JUST WON'T LET IT DROP...

ARE YOU *RECEIVING* ME? ANYONE?

...*HOT ROD'S* BACK ON HIS FEET, BUT THERE'S STILL NO WORD ON *IRONHIDE*.

DEAD OR ALIVE, HE SEEMS TO HAVE DROPPED *OFF* THE FACE OF THE EARTH.

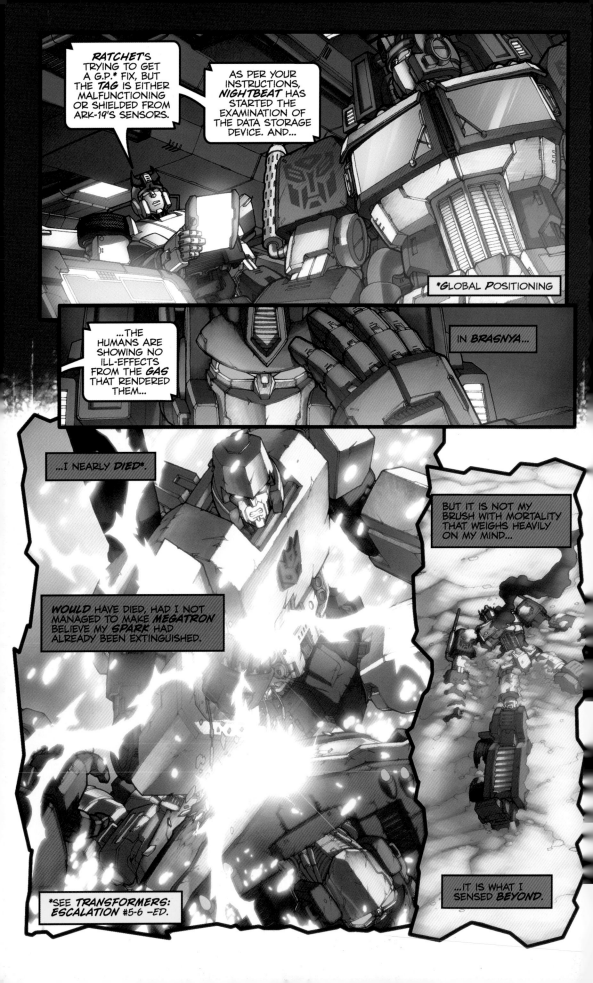

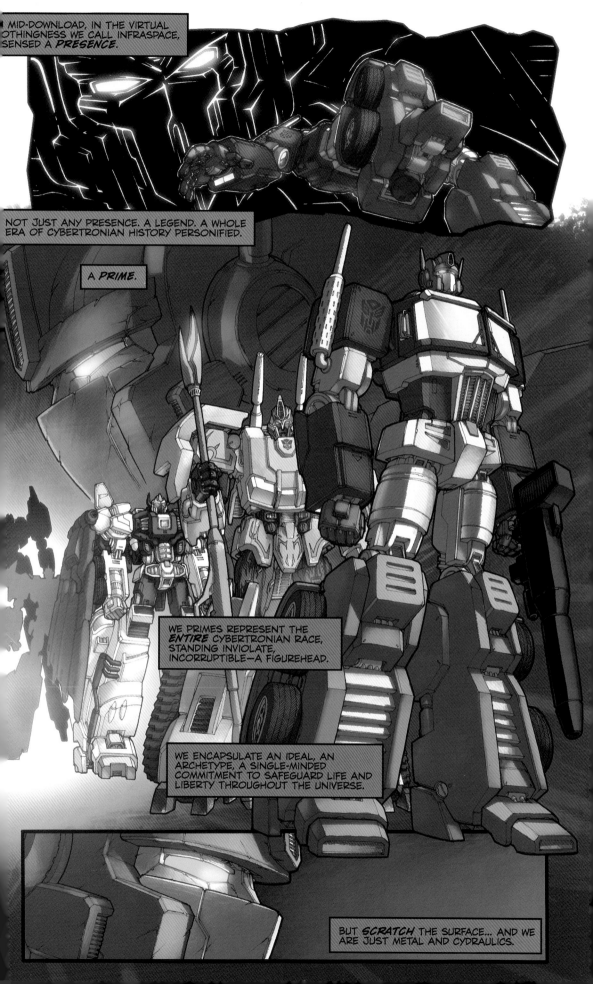

MID-DOWNLOAD, IN THE VIRTUAL NOTHINGNESS WE CALL INFRASPACE, I SENSED A *PRESENCE.*

NOT JUST ANY PRESENCE. A LEGEND. A WHOLE ERA OF CYBERTRONIAN HISTORY PERSONIFIED.

A *PRIME.*

WE PRIMES REPRESENT THE *ENTIRE* CYBERTRONIAN RACE, STANDING INVIOLATE, INCORRUPTIBLE—A FIGUREHEAD.

WE ENCAPSULATE AN IDEAL, AN ARCHETYPE, A SINGLE-MINDED COMMITMENT TO SAFEGUARD LIFE AND LIBERTY THROUGHOUT THE UNIVERSE.

BUT *SCRATCH* THE SURFACE... AND WE ARE JUST METAL AND CYDRAULICS.

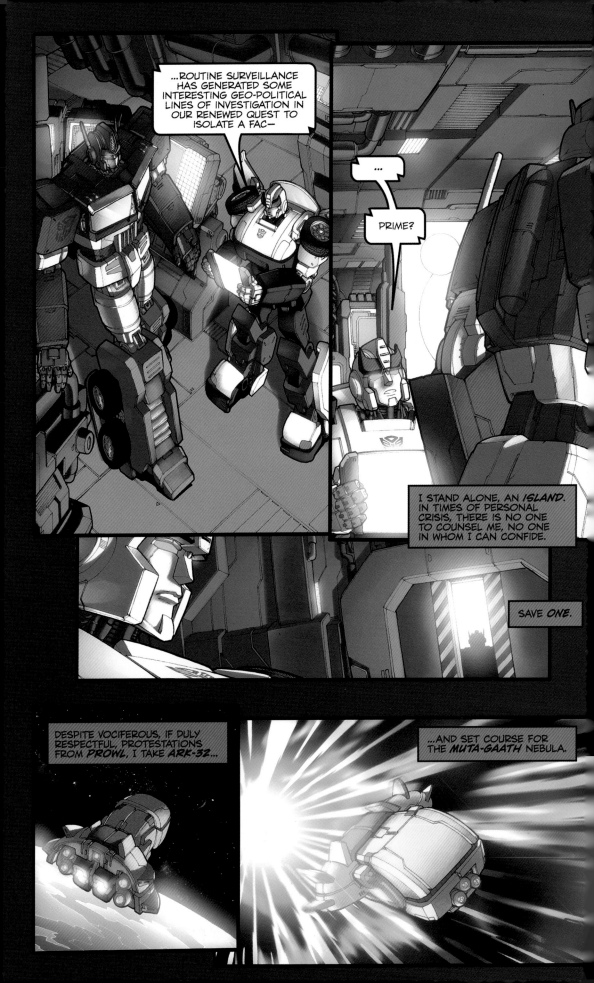

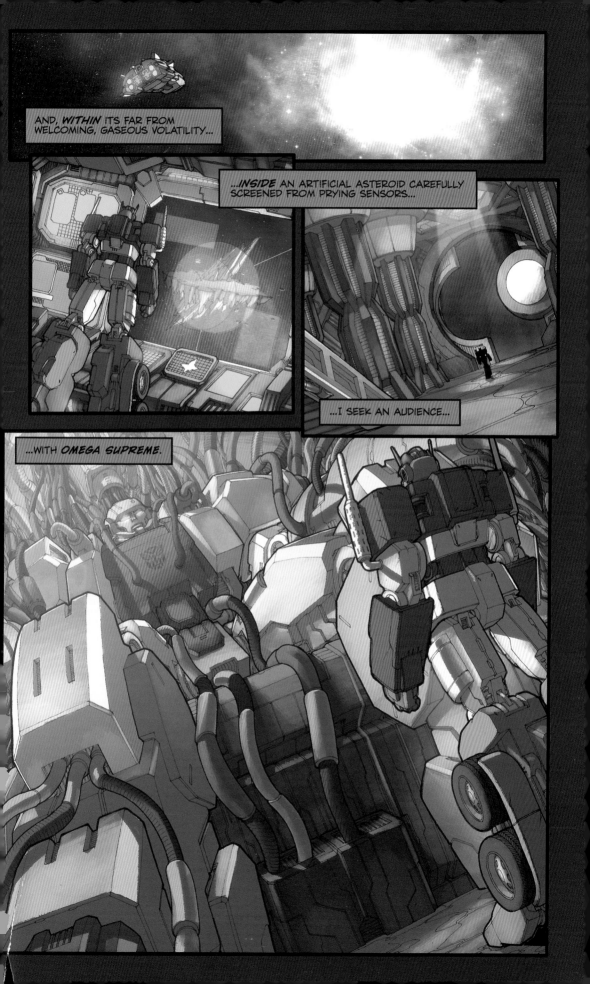

AND, *WITHIN* ITS FAR FROM WELCOMING, GASEOUS VOLATILITY...

...*INSIDE* AN ARTIFICIAL ASTEROID CAREFULLY SCREENED FROM PRYING SENSORS...

...I SEEK AN AUDIENCE...

...WITH *OMEGA SUPREME.*

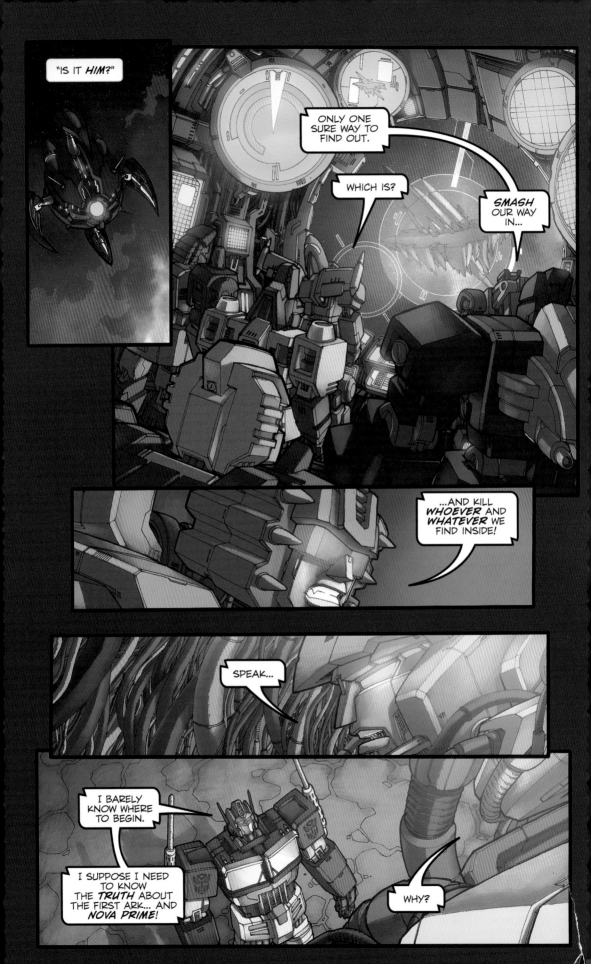

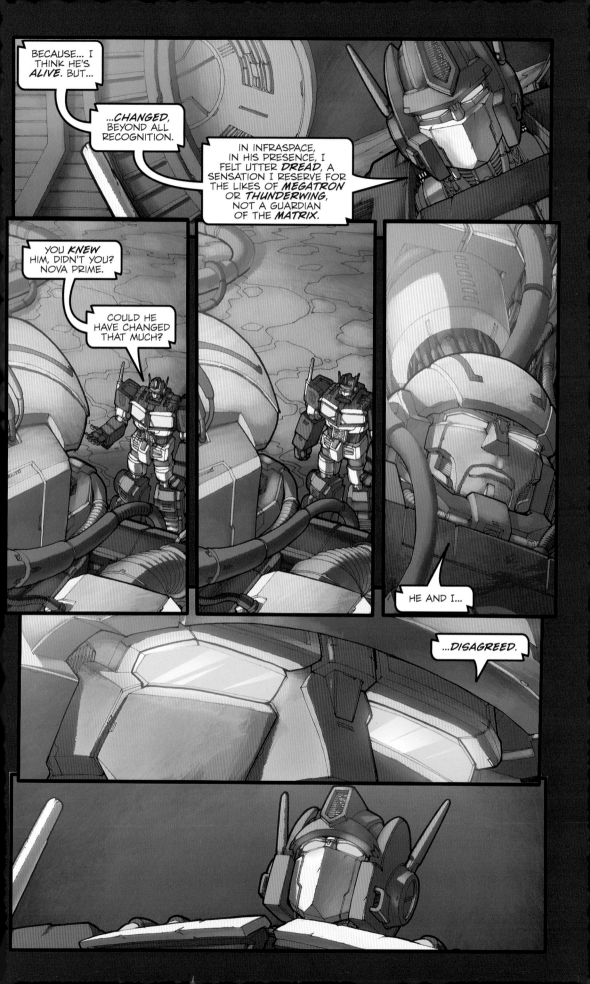

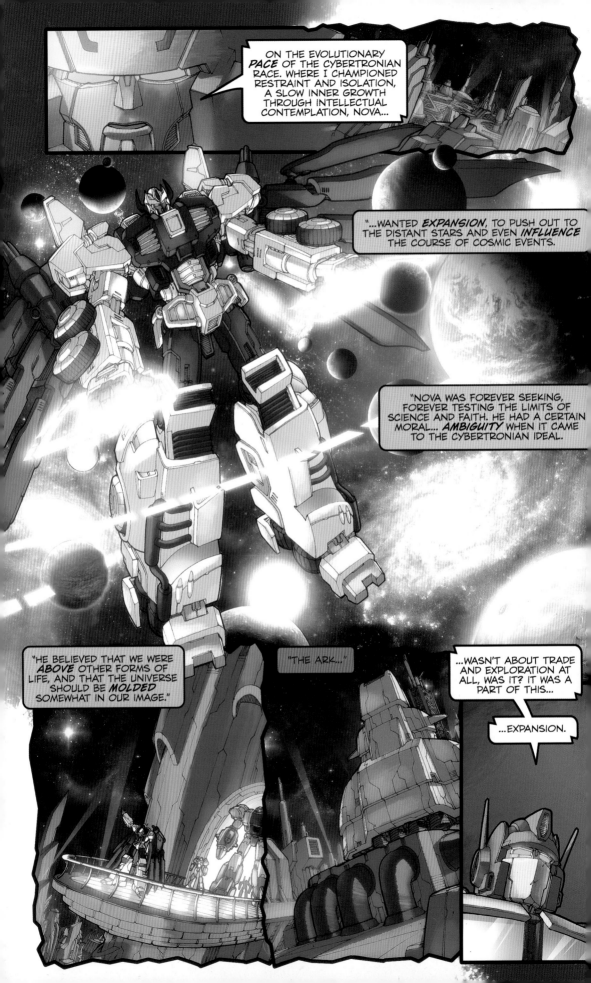

ON THE EVOLUTIONARY *PACE* OF THE CYBERTRONIAN RACE. WHERE I CHAMPIONED RESTRAINT AND ISOLATION, A SLOW INNER GROWTH THROUGH INTELLECTUAL CONTEMPLATION, NOVA...

"...WANTED *EXPANSION*, TO PUSH OUT TO THE DISTANT STARS AND EVEN *INFLUENCE* THE COURSE OF COSMIC EVENTS.

"NOVA WAS FOREVER SEEKING, FOREVER TESTING THE LIMITS OF SCIENCE AND FAITH. HE HAD A CERTAIN MORAL... *AMBIGUITY* WHEN IT CAME TO THE CYBERTRONIAN IDEAL.

"HE BELIEVED THAT WE WERE *ABOVE* OTHER FORMS OF LIFE, AND THAT THE UNIVERSE SHOULD BE *MOLDED* SOMEWHAT IN OUR IMAGE."

"THE ARK..."

...WASN'T ABOUT TRADE AND EXPLORATION AT ALL, WAS IT? IT WAS A PART OF THIS...

...EXPANSION.

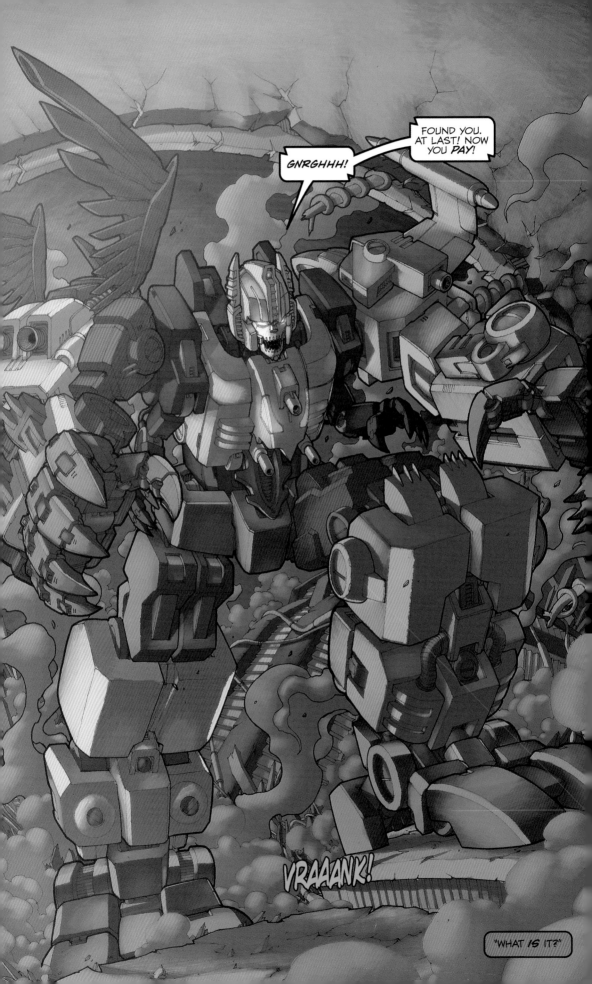

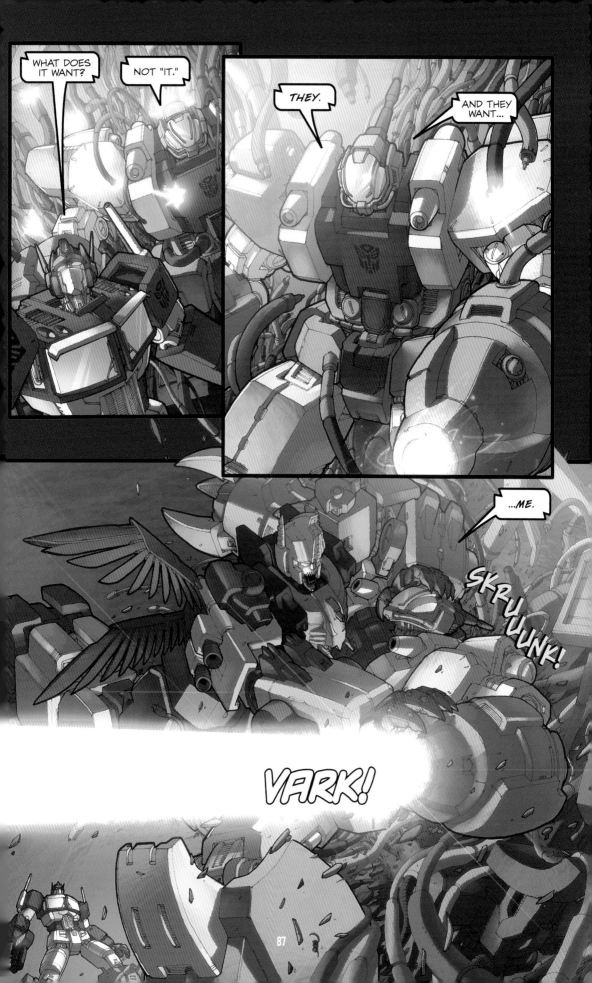

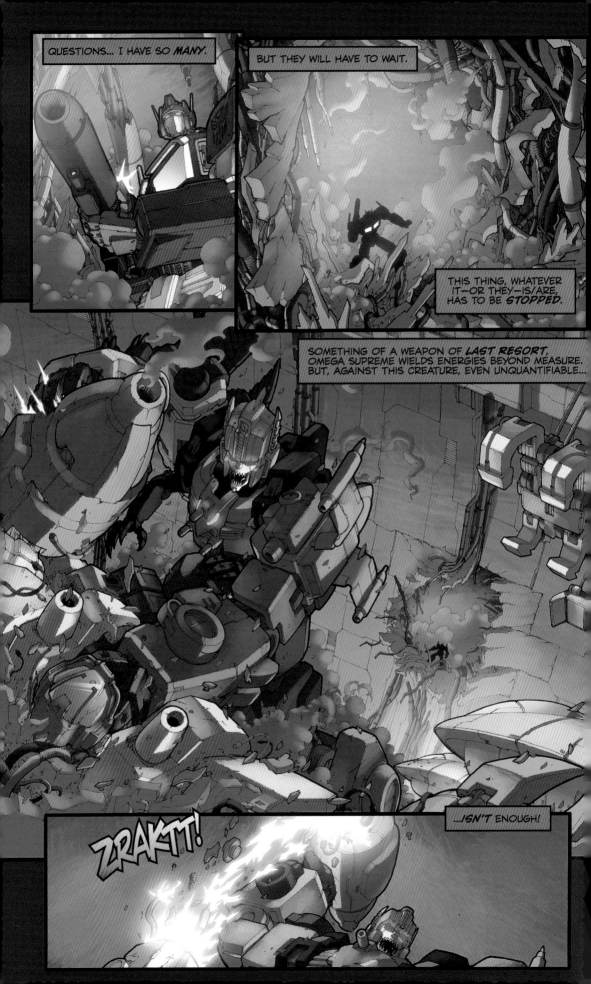

QUESTIONS... I HAVE SO *MANY*.

BUT THEY WILL HAVE TO WAIT.

THIS THING, WHATEVER IT—OR THEY—IS/ARE, HAS TO BE *STOPPED*.

SOMETHING OF A WEAPON OF *LAST RESORT*, OMEGA SUPREME WIELDS ENERGIES BEYOND MEASURE. BUT, AGAINST THIS CREATURE, EVEN UNQUANTIFIABLE...

...*ISN'T* ENOUGH!

ZRAKTT!

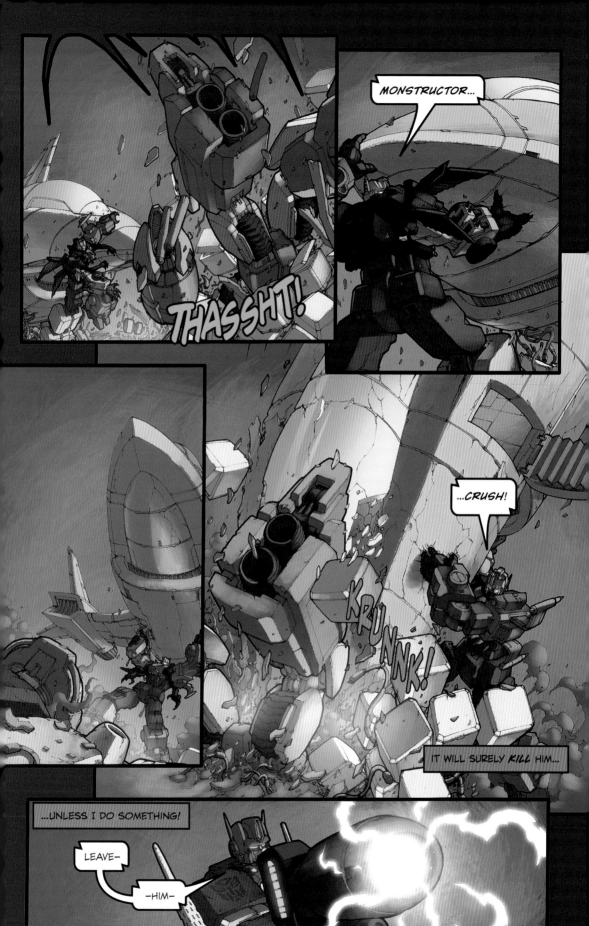

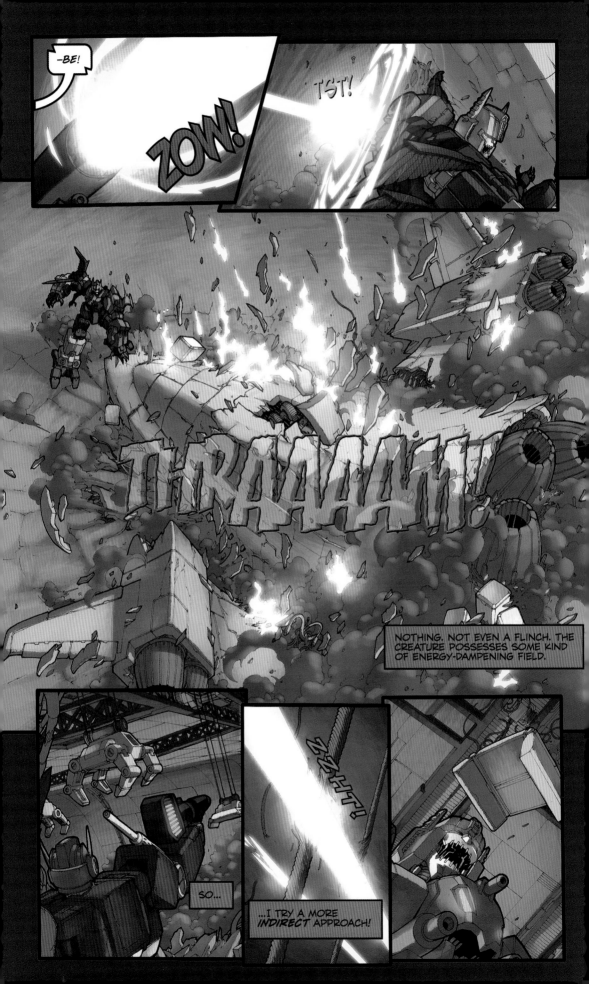

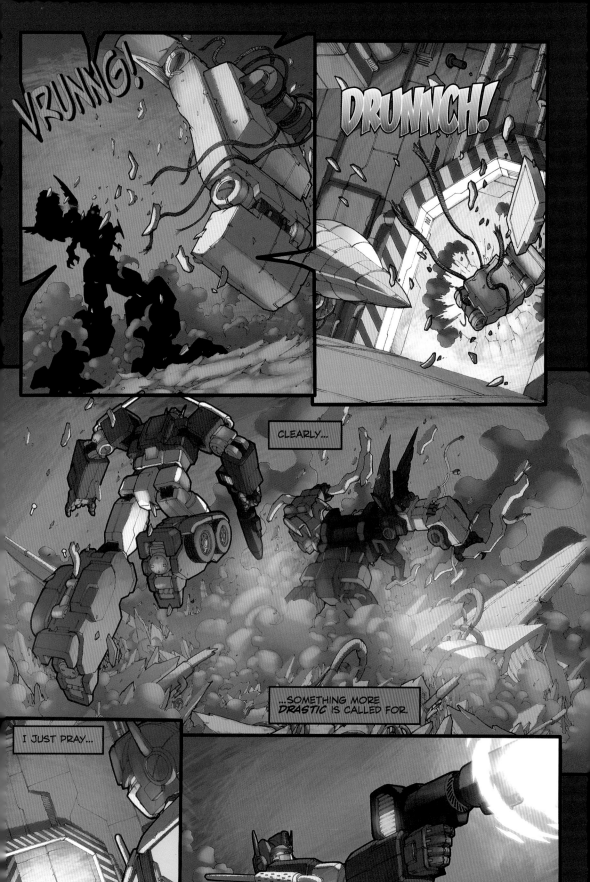

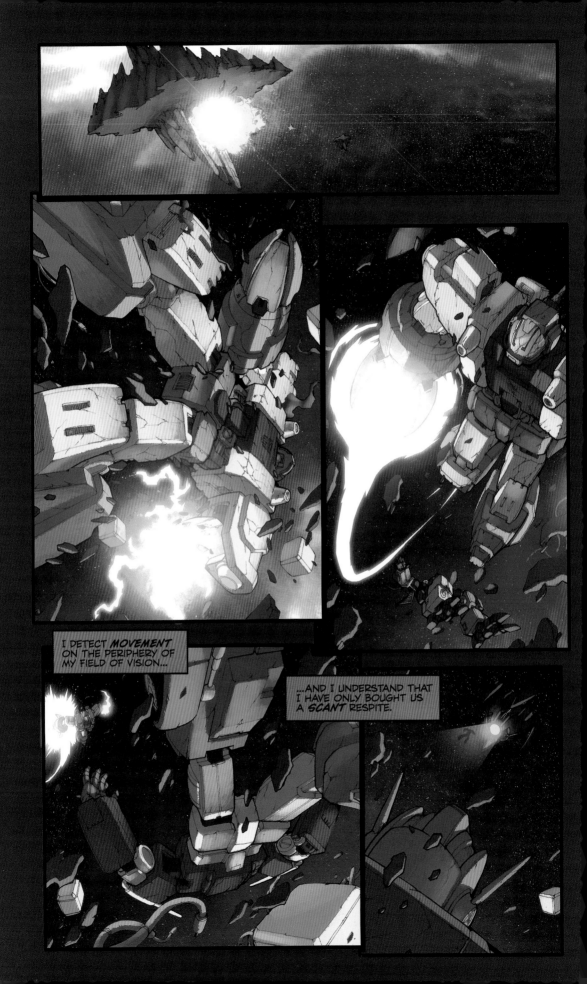

I DETECT *MOVEMENT* ON THE PERIPHERY OF MY FIELD OF VISION...

...AND I UNDERSTAND THAT I HAVE ONLY BOUGHT US A *SCANT* RESPITE.

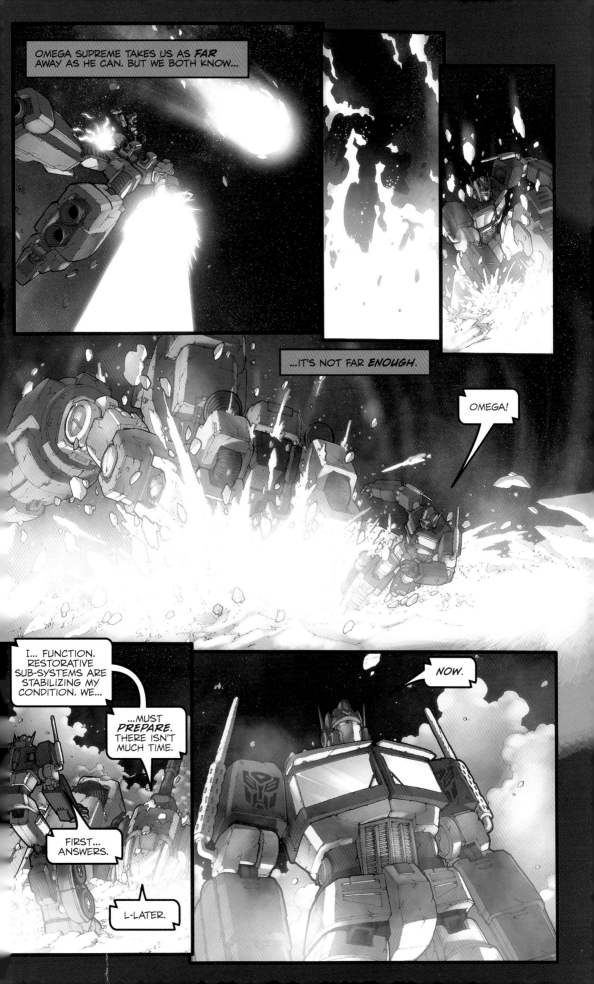

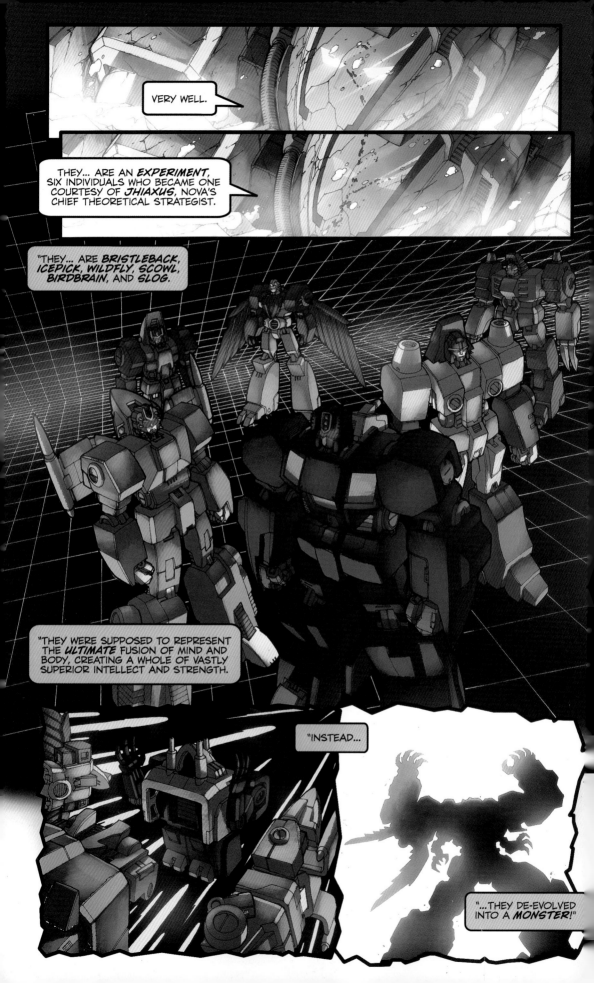

VERY WELL.

THEY... ARE AN *EXPERIMENT*, SIX INDIVIDUALS WHO BECAME ONE COURTESY OF *JHIAXUS*, NOVA'S CHIEF THEORETICAL STRATEGIST.

"THEY... ARE *BRISTLEBACK*, *ICEPICK*, *WILDFLY*, *SCOWL*, *BIRDBRAIN*, AND *SLOG*.

"THEY WERE SUPPOSED TO REPRESENT THE *ULTIMATE* FUSION OF MIND AND BODY, CREATING A WHOLE OF VASTLY SUPERIOR INTELLECT AND STRENGTH.

"INSTEAD...

"...THEY DE-EVOLVED INTO A *MONSTER!*"

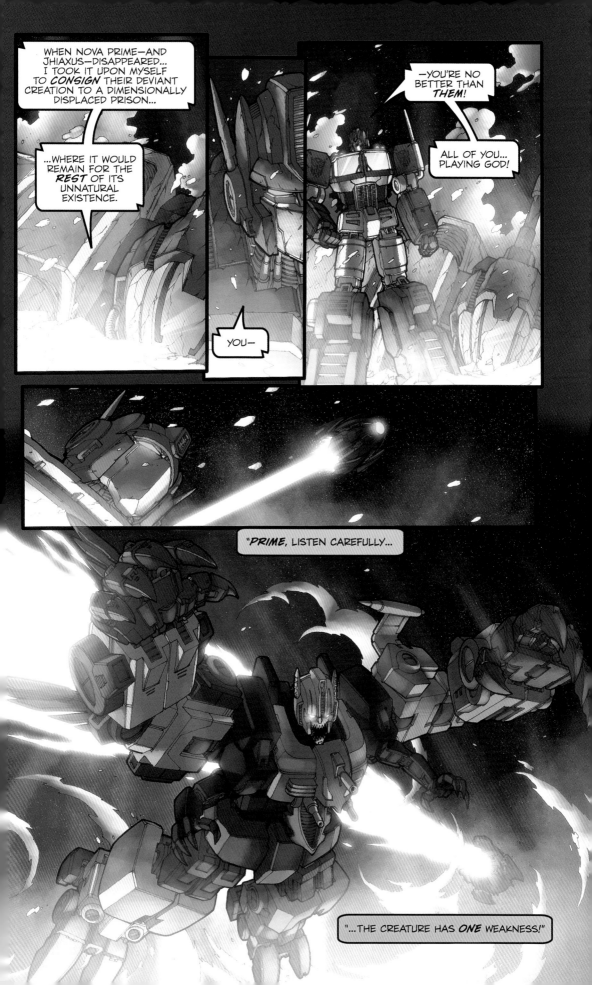

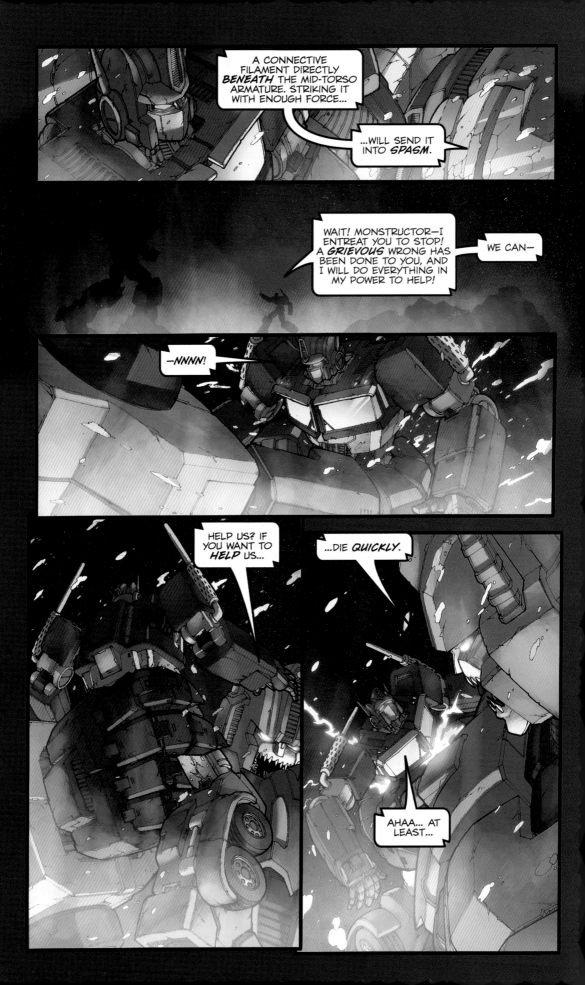

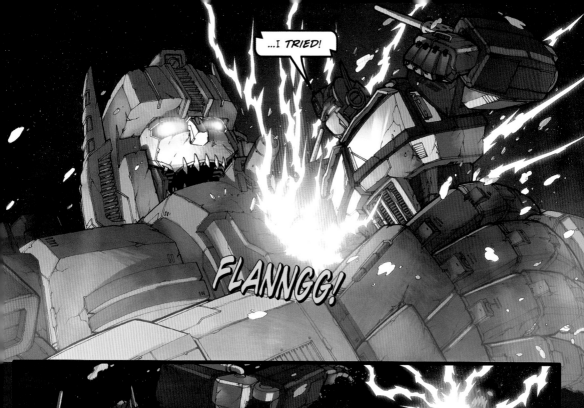

RAMJET.
A lone-wolf DECEPTICON whose plans involve nothing less than
the overthrow of MEGATRON himself. But is RAMJET the master
schemer he believes, or just another pretender to the throne?
One way or another, he is about to find out.

RAMJET

Written by Stuart Moore Art by Robby Musso

GREENWICH MEAN TIME: 3:54 PM

LOCAL TIME: 8:54 AM

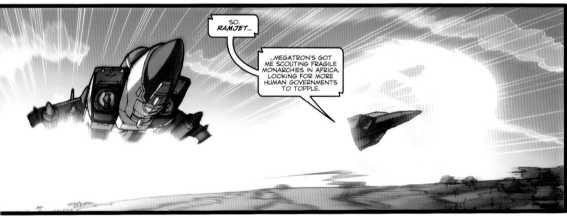

SO, *RAMJET*...

...MEGATRON'S GOT ME SCOUTING FRAGILE MONARCHIES IN AFRICA. LOOKING FOR MORE HUMAN GOVERNMENTS TO TOPPLE.

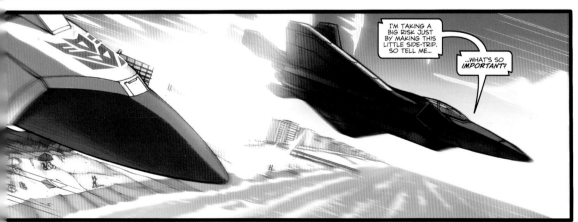

I'M TAKING A BIG RISK JUST BY MAKING THIS LITTLE SIDE-TRIP. SO TELL ME...

...WHAT'S SO *IMPORTANT*?

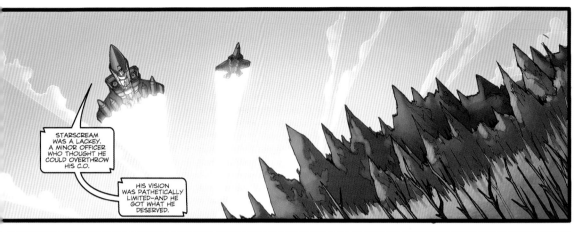

STARSCREAM WAS A LACKEY. A MINOR OFFICER WHO THOUGHT HE COULD OVERTHROW HIS C.O.

HIS VISION WAS PATHETICALLY LIMITED—AND HE GOT WHAT HE DESERVED.

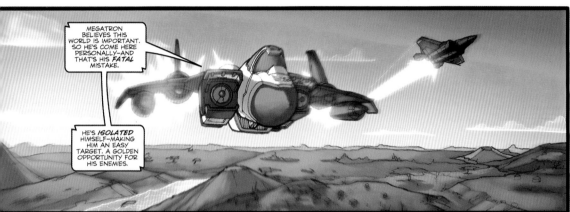

MEGATRON BELIEVES THIS WORLD IS IMPORTANT. SO HE'S COME HERE PERSONALLY—AND THAT'S HIS *FATAL* MISTAKE.

HE'S *ISOLATED* HIMSELF—MAKING HIM AN EASY TARGET. A GOLDEN OPPORTUNITY FOR HIS ENEMIES.

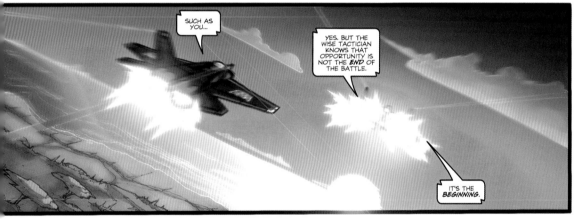

SUCH AS YOU...

YES. BUT THE WISE TACTICIAN KNOWS THAT OPPORTUNITY IS NOT THE *END* OF THE BATTLE.

IT'S THE *BEGINNING.*

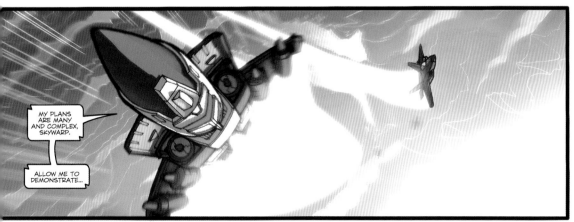

MY PLANS ARE MANY AND COMPLEX, SKYWARP.

ALLOW ME TO DEMONSTRATE...

WHEN A DECEPTICON—YOU OR I—FLIES FROM PLACE TO PLACE, THE PROCESS IS BASICALLY *LINEAR*. THREE-DIMENSIONAL.

AS YOU SOAR OVER LAND, THE OCEAN AHEAD CAN BE PLAINLY SEEN. THE ATMOSPHERE AROUND YOU GIVES WAY GRADUALLY TO THE AIRLESS VOID ABOVE.

BUT WHEN WE PERFORM AN ORBITAL BOUNCE—OR WHEN YOU, YOURSELF, TRAVEL THROUGH ONE OF YOUR SPATIAL WARPS—

—WE APPEAR, SUDDENLY, TO BE EVERYWHERE AT ONCE.

MEGATRON'S PLANS, STARSCREAM'S—THOSE CONCEPTS ARE LIMITED AND THREE-DIMENSIONAL.

MINE ARE MUCH LARGER... MORE COMPLEX. LESS *LINEAR*.

THAT IS WHY, SKYWARD... I WILL ULTIMATELY TRIUMPH.

HA! YOU KNOW WHAT, RAMJET?

THAT'S THE BIGGEST BUNCH OF CRAP I'VE EVER HEARD.

I'M INTRIGUED, THOUGH. TELL YOU WHAT...

...I'LL CHECK BACK WITH YOU IN ONE EARTH SOLAR-CYCLE.

IF YOUR "PLANS" ARE LOOKING "NONLINEAR" ENOUGH BY THEN... MAYBE WE'LL TALK.

YOU MIGHT WANT TO REMEMBER THE OLD CYBERTRONIAN SAYING, THOUGH...

"...ALWAYS BET ON THE LEADER."

ONE EARTH SOLAR-CYCLE. TWENTY-FOUR HOURS.

THAT SHOULD BE JUST ENOUGH TIME...

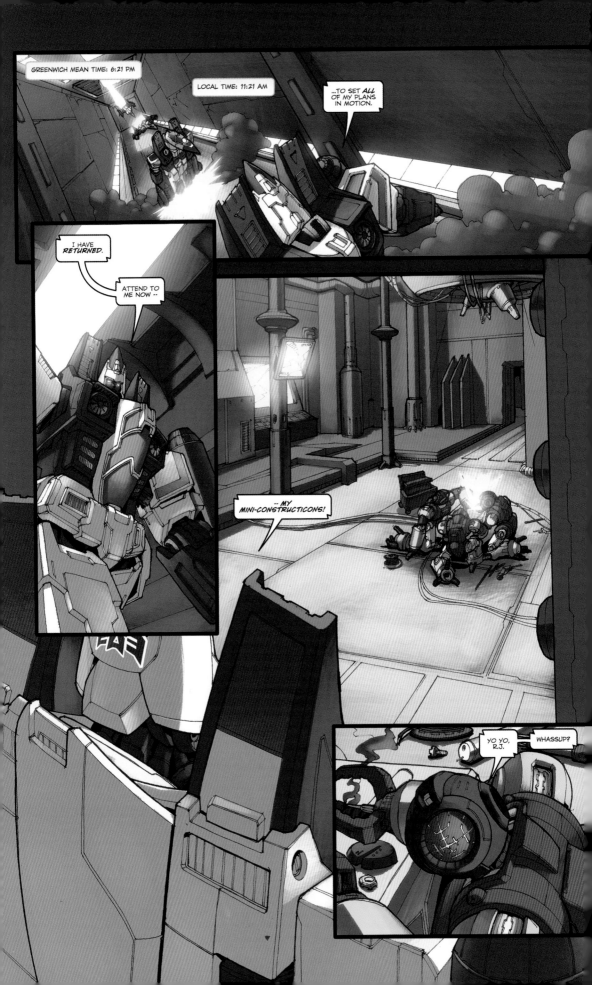

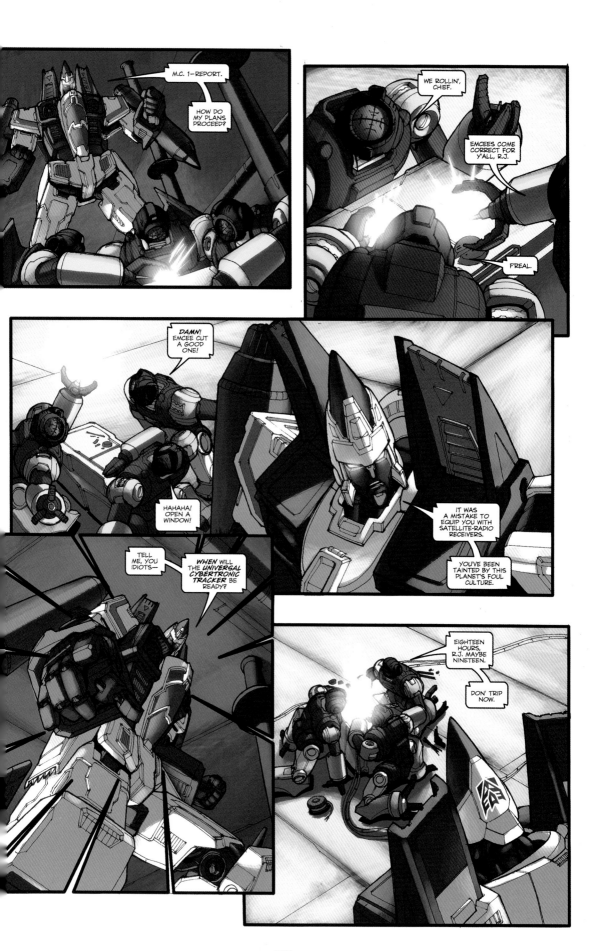

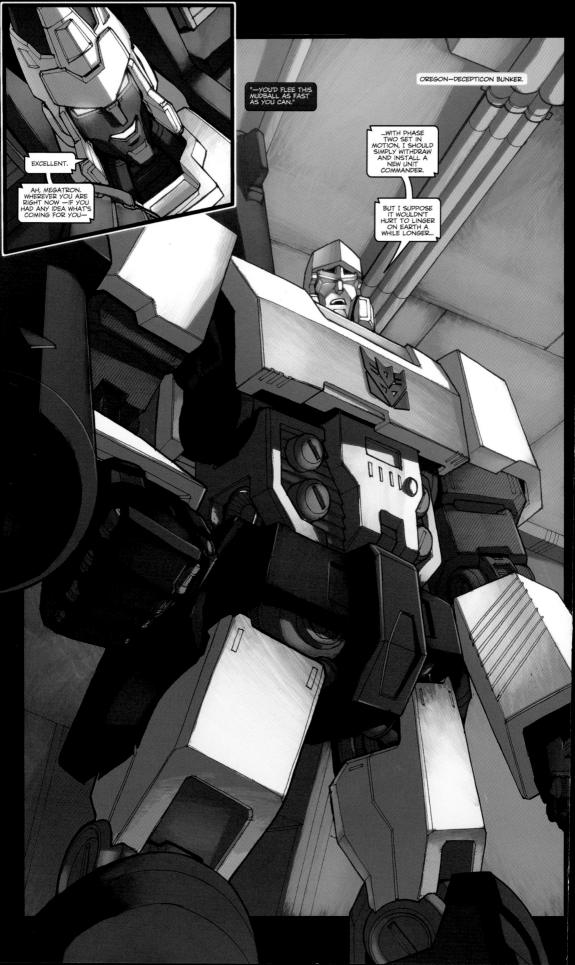

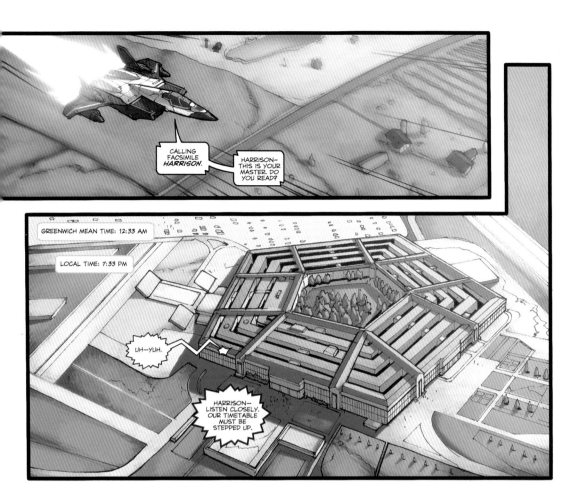

CALLING FACSIMILE *HARRISON.*

HARRISON— THIS IS YOUR MASTER. DO YOU READ?

GREENWICH MEAN TIME: 12:33 AM

LOCAL TIME: 7:33 PM

UH—YUH.

HARRISON— LISTEN CLOSELY. OUR TIMETABLE MUST BE STEPPED UP.

MY PLANS ARE APPROACHING FRUITION. LIKE A BEAUTIFUL MOSAIC, THEY REACH ACROSS TIME AND SPACE...

...AND *YOU* ARE A VITAL PART OF THEM.

ARE YOU READY?

UH...

GUH?

HARRISON, PLEASE FOCUS. YOU ARE A HUMAN FACSIMILE IN MY EMPLOY—AN ARTIFICIAL MAN.

CONSTRUCTED, SADLY, WITH EQUIPMENT *INFERIOR* TO THAT USED BY THE OTHER DECEPTICONS.

NEVERTHELESS, YOUR POSITION ON THE PENTAGON'S CLERICAL STAFF IS CRUCIAL TO MY PLANS.

YUH?

WHAT'S WITH *THAT* GUY?

AH.

I HEAR HE'S A NEW HIRE. HOLLYWOOD UNIVERSITY.

WHEN I GIVE THE WORD—I NEED YOU TO MEET ME AT THE PRE-ARRANGED LOCATION—

—WITH THE REMOTE MISSILE-LAUNCHER CODES YOU ACQUIRED LAST WEEK.

HARRISON: *CAN YOU DO THAT?*

UH...

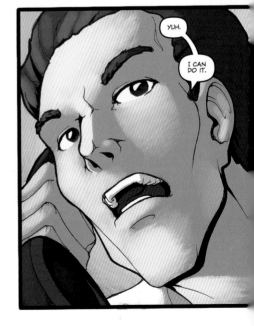

YUH.

I CAN DO IT.

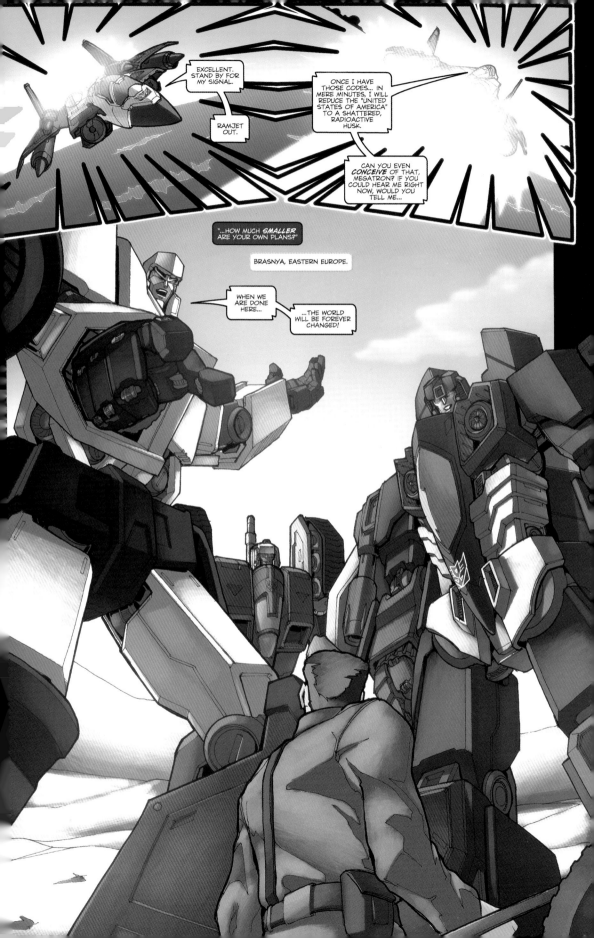

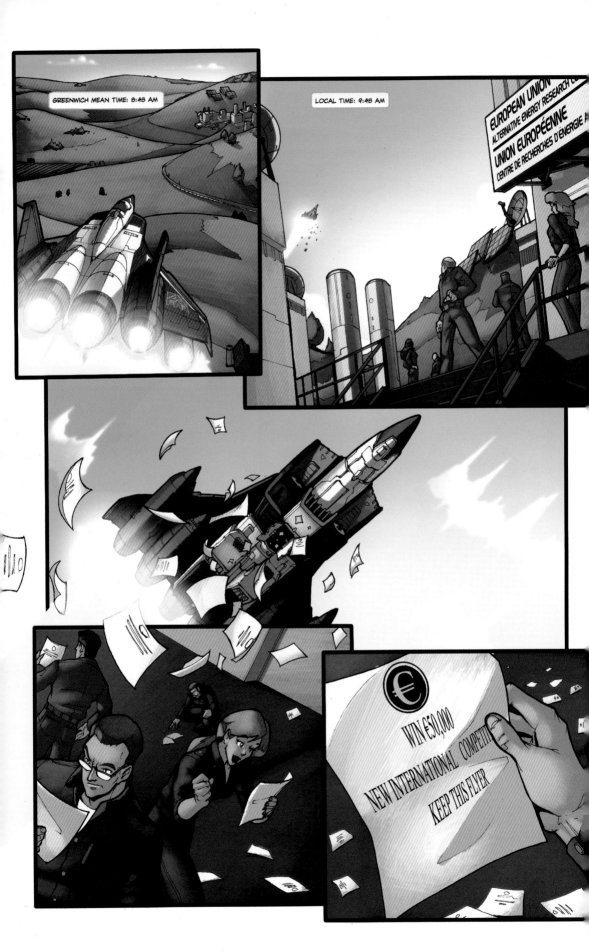

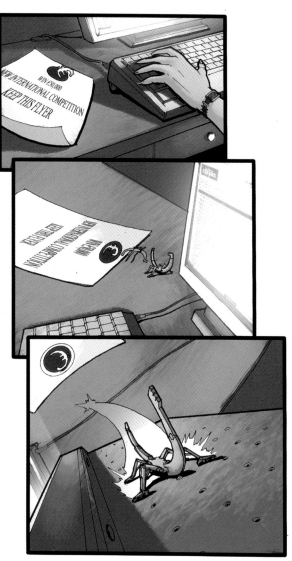

EXCELLENT.

FOUR HUNDRED TWENTY-ONE ELECTRONIC LISTENING DEVICES... PLANTED INSIDE THE MOST ADVANCED ENERGY RESEARCH FACILITY ON THIS PLANET.

SOONER OR LATER, THOSE HUMANS WILL DEVISE A SUBSTANCE THAT CAN BE CONVERTED INTO AN *ENERGON* SUBSTITUTE.

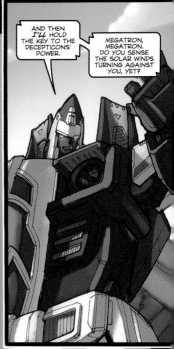

AND THEN *I'LL* HOLD THE KEY TO THE DECEPTICONS' POWER.

MEGATRON, MEGATRON, DO YOU SENSE THE SOLAR WINDS TURNING AGAINST YOU, YET?

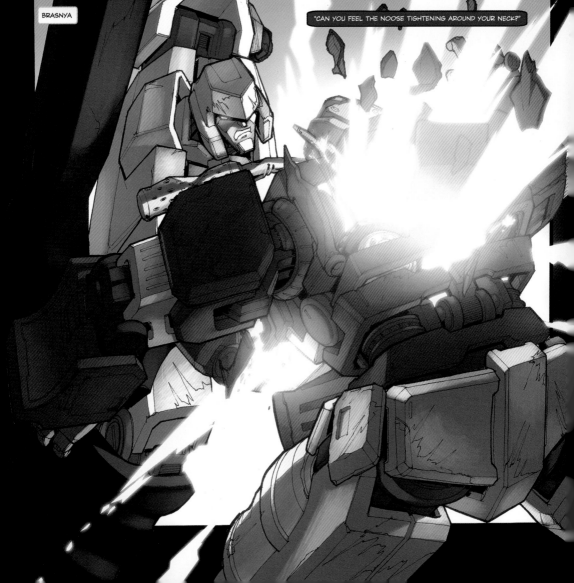

BRASNYA

"CAN YOU FEEL THE NOOSE TIGHTENING AROUND YOUR NECK?"

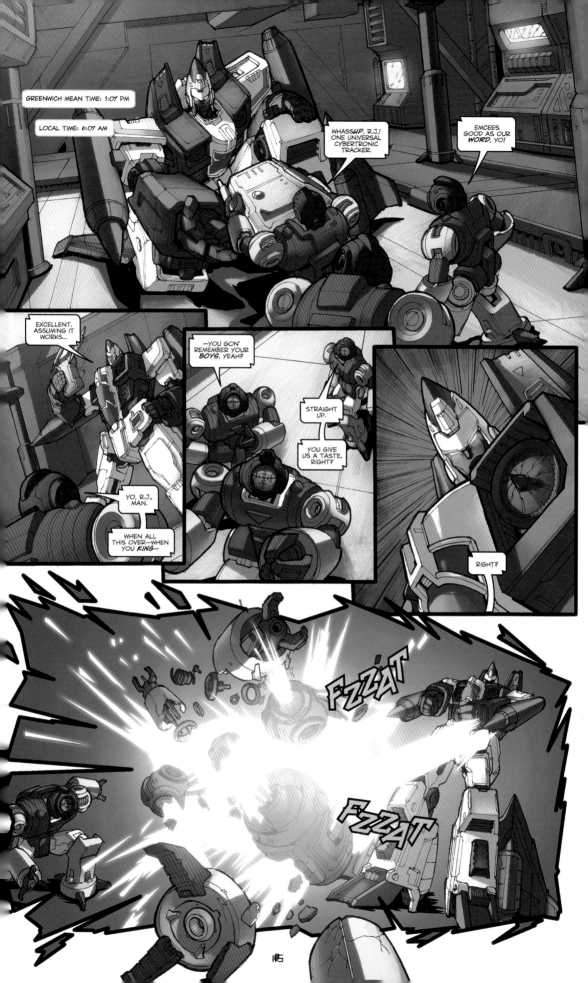

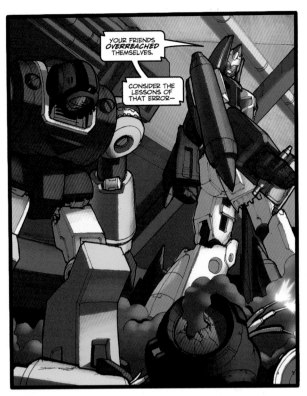

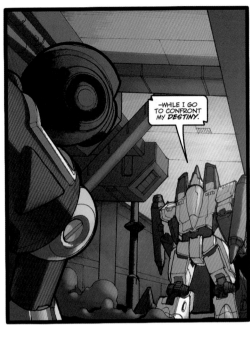

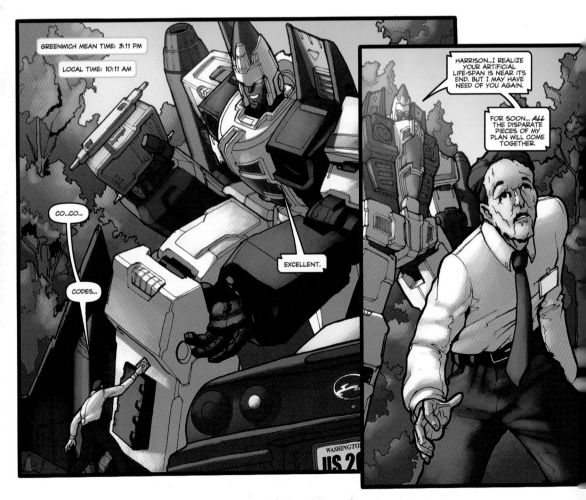

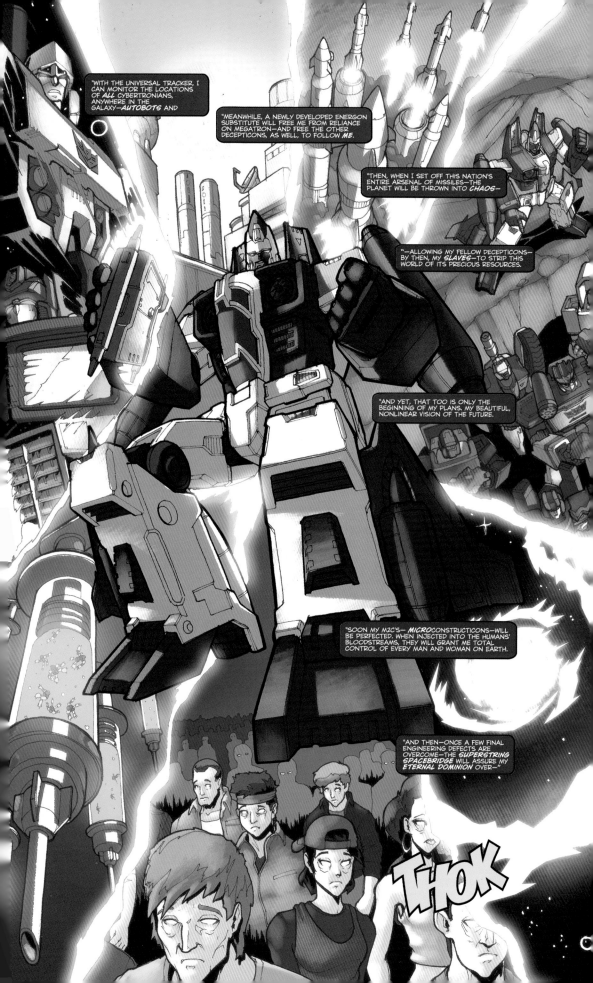

"WITH THE UNIVERSAL TRACKER, I CAN MONITOR THE LOCATIONS OF *ALL* CYBERTRONIANS, ANYWHERE IN THE GALAXY—*AUTOBOTS* AND

"MEANWHILE, A NEWLY DEVELOPED ENERGON SUBSTITUTE WILL FREE ME FROM RELIANCE ON MEGATRON—AND FREE THE OTHER DECEPTICONS, AS WELL, TO FOLLOW *ME*.

"THEN, WHEN I SET OFF THIS NATION'S ENTIRE ARSENAL OF MISSILES—THE PLANET WILL BE THROWN INTO *CHAOS*—

"—ALLOWING MY FELLOW DECEPTICONS— BY THEN, MY *SLAVES*—TO STRIP THIS WORLD OF ITS PRECIOUS RESOURCES.

"AND YET, THAT TOO IS ONLY THE BEGINNING OF MY PLANS. MY BEAUTIFUL, NONLINEAR VISION OF THE FUTURE.

"SOON MY M2C'S— *MICRO*CONSTRUCTICONS—WILL BE PERFECTED. WHEN INJECTED INTO THE HUMANS' BLOODSTREAMS, THEY WILL GRANT ME TOTAL CONTROL OF EVERY MAN AND WOMAN ON EARTH.

"AND THEN—ONCE A FEW FINAL ENGINEERING DEFECTS ARE OVERCOME—THE *SUPERSTRING SPACEBRIDGE* WILL ASSURE MY *ETERNAL DOMINION* OVER—"

THOK

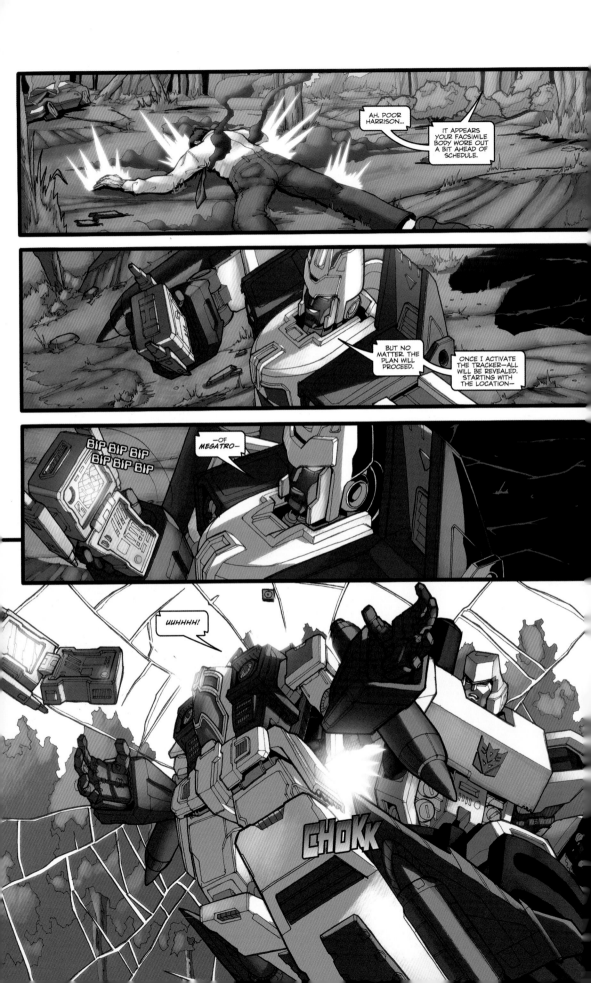

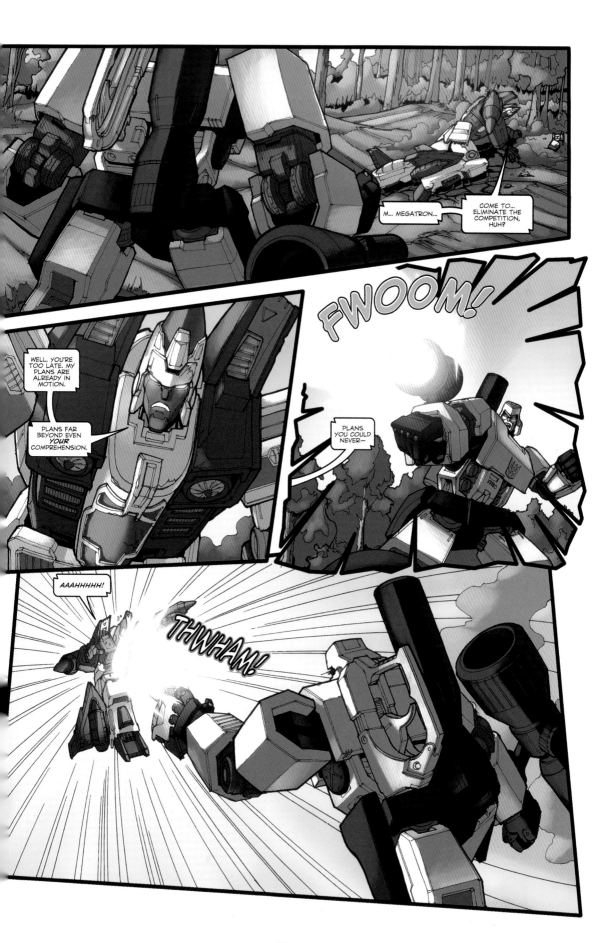

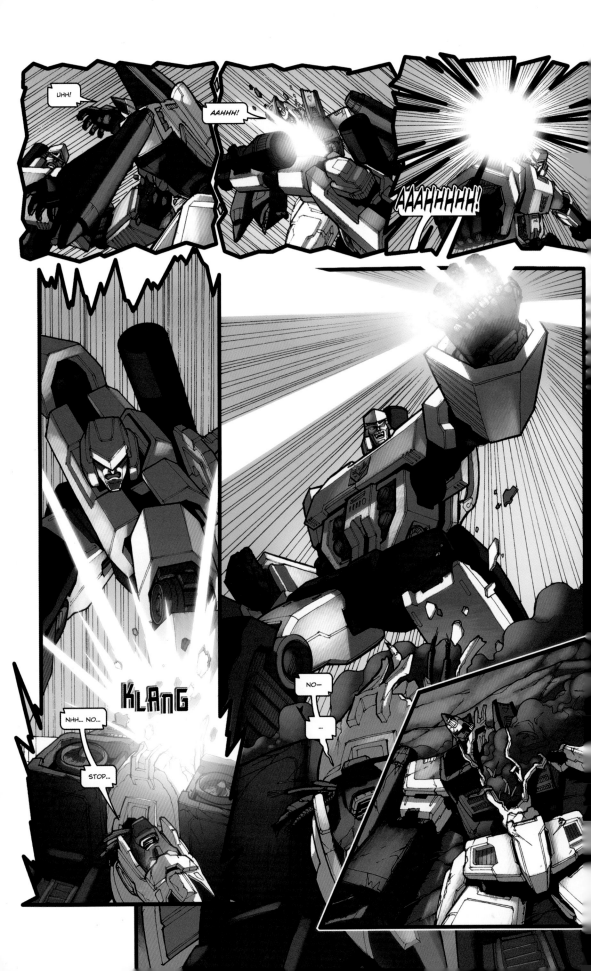

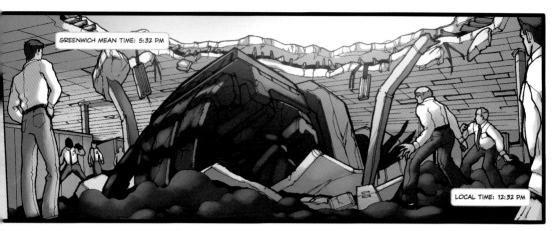

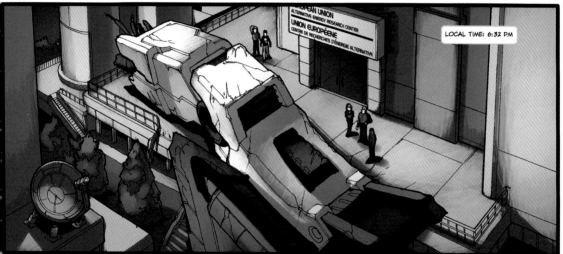

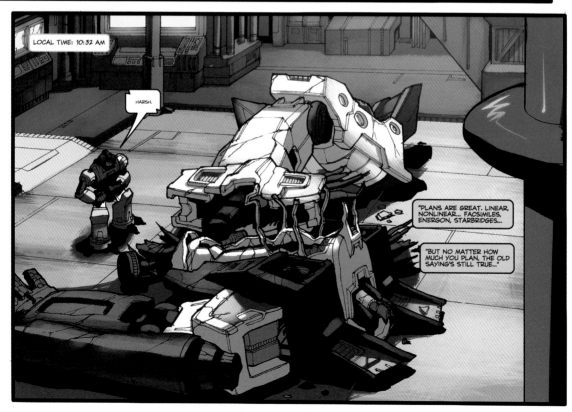

121

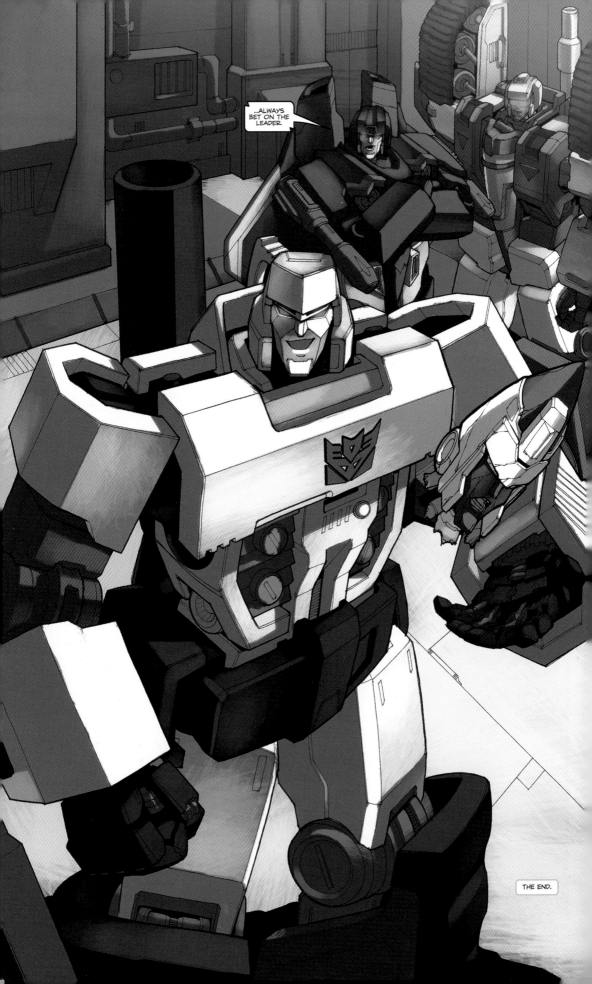

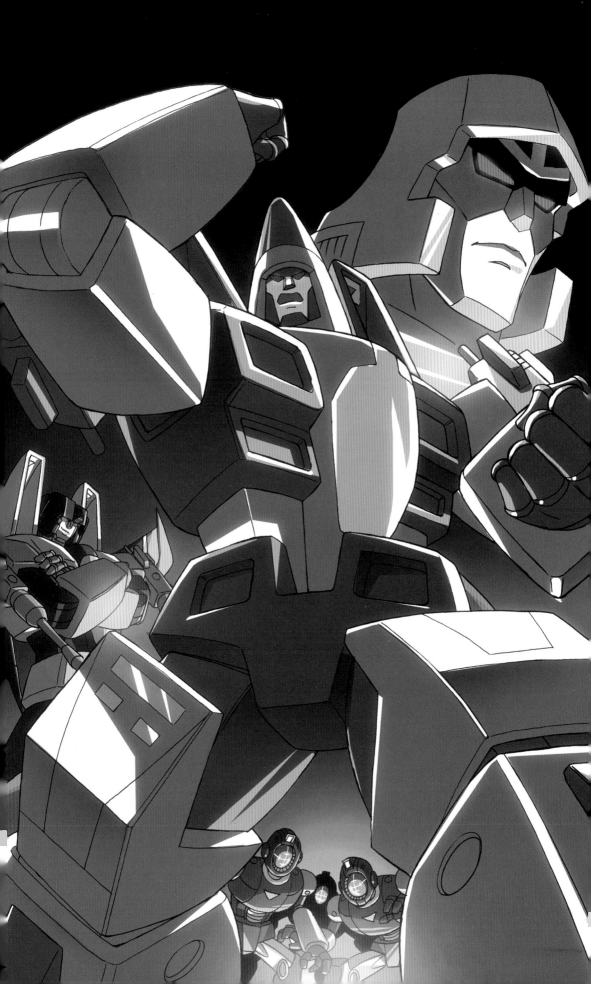

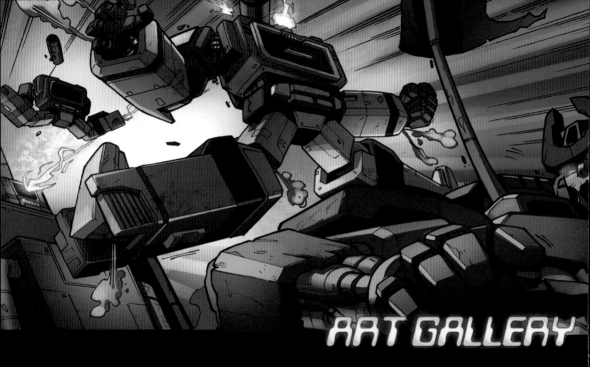

ART GALLERY

Art by Marcelo Martere

Art by Nick Roche

Art by Marcelo Matere

KUP

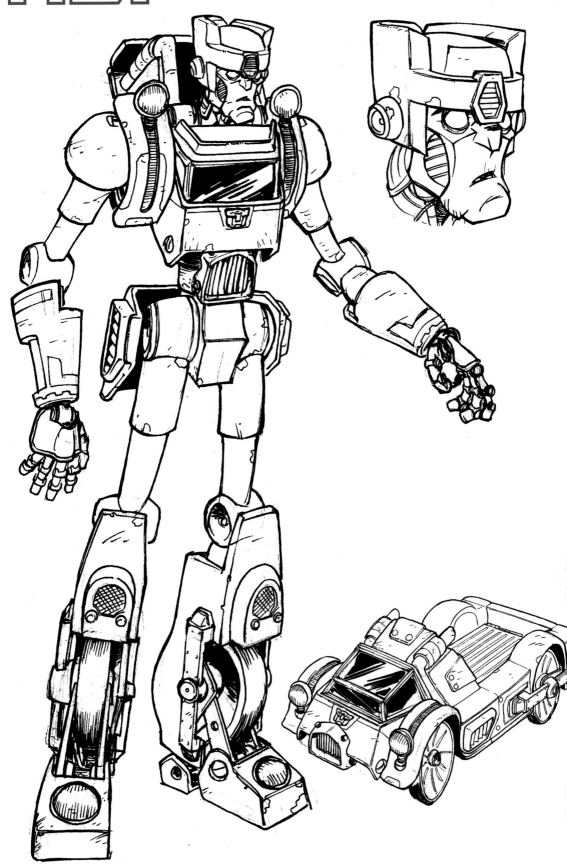

Art by Nick Roche

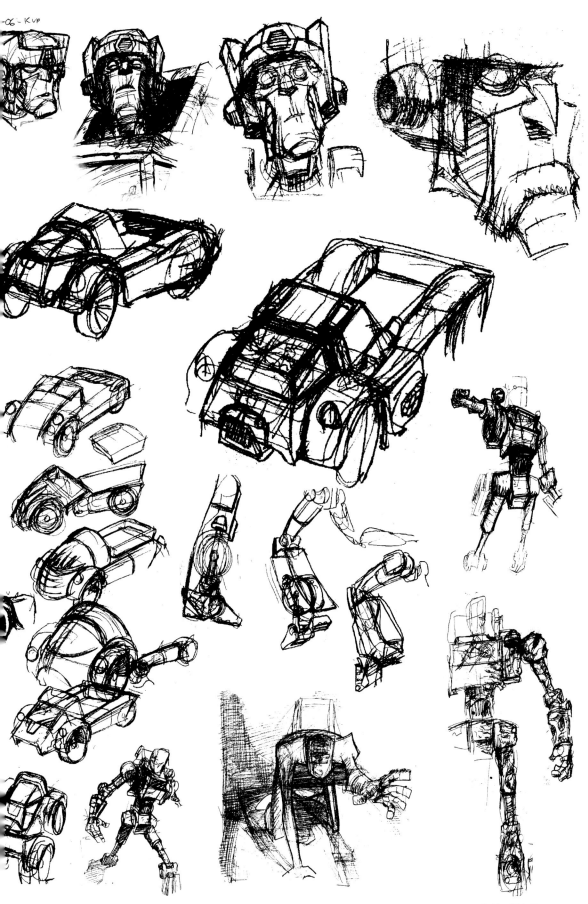

-06 - KUP

Art by Nick Roche

GALVATRON

HOUND
Cybertronian robot mode

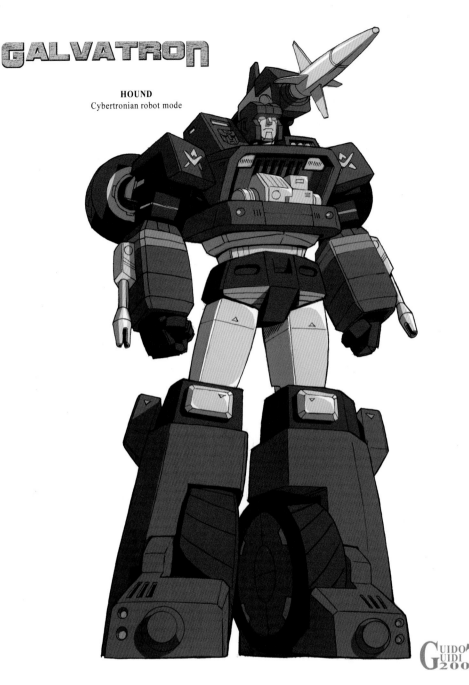

HOUND
Cybertronian vehicle mode

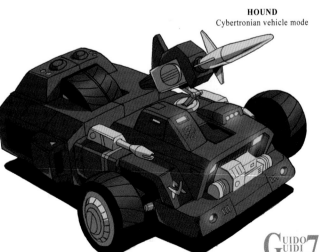

Art by Guido Guidi

SKRAM
Cybertronian robot mode

SKRAM
Cybertronian vehicle mode

Art by Guido Guidi

OPTIMUS PRIME

SENTINEL PRIME

Art by Don Figueroa

Art by Don Figueroa

RAMJET

R·Musso